SCULPTURE
FROM
FOUND
OBJECTS

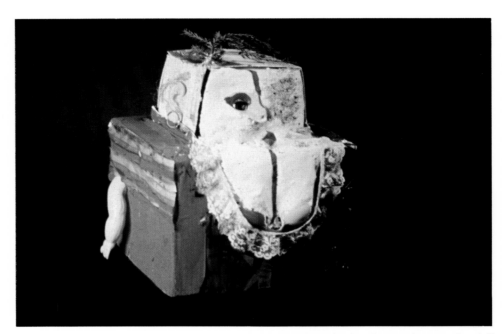

A box, a berry basket, lace and parts of a doll made this sophisticated lady. East High School, Rochester, N.Y.

SCULPTURE
FROM
FOUND
OBJECTS

Carl Reed

Co-ordinator, MAT in Art Education
University of Massachusetts

Burt Towne

Art Director,
Rochester, New York Public Schools

DAVIS PUBLICATIONS, INC.
WORCESTER, MASSACHUSETTS

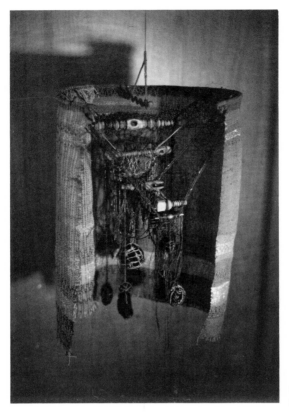

"Inside Outside" by Brita. Caged stones and turned wood of an old spinning wheel hang inside the woven form.

Davis Publications, Inc.
Worcester, Massachusetts, U.S.A.

Printed in the United States of America
Library of Congress Catalog Card Number: 73-93382
ISBN 0-87192-056-5

Printing: The Art Print Co.
Type: 12/14 Newton Light & 9/10 Univers Medium Italic
Graphic Design by: Repro Art Service

Consulting Editors: George F. Horn, Sarita R. Rainey

10 9 8 7 6 5 4 3 2 1

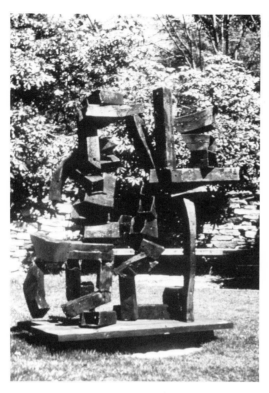

"Frames" by Sid Poritz. Welded auto frame allowed to rust provide changing colorations.

CONTENTS

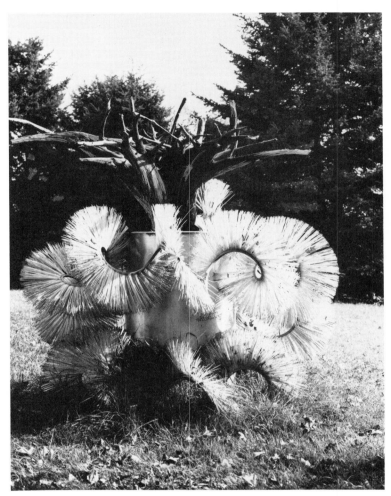

"Assemblage" by Ray Miles.

A sand casting by Diane Halvey.

PREFACE

This book was developed to provide a stimulating, informative and visual resource for young artists . . . of all ages . . . who might derive benefits from being exposed to the range of possibilities for sculpturing with found objects and/or containers.

Perhaps the genesis of the idea for a book on sculpture, which could be created with cast-off materials, evolved from a personal collection of antique tools and discarded objects of interesting forms. This collection seemed to have taken on the appearance of a museum-like display of abstract sculpture. The notion of a book was given additional impetus by the enormous variety of disposable containers challenging the imagination as to how they could be used as sculpture materials, rather than relegating them to the rubbish heap. Personal

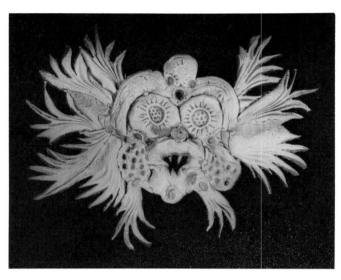

Dough sculpture by Pamela Pomeroy.

experiments with containers as the basic form for sculptures resulted in some interesting pieces, some of which are included in this book. When plastic and cardboard containers were provided to students for their exploration as sculpture materials, they responded enthusiastically and produced exciting and imaginative creations. Thus it was decided to assemble photos of works by mature artists and youngsters who have successfully used discarded materials and so this book, its direction, and title . . . SCULPTURE FROM FOUND OBJECTS.

Then my colleague, Burt Towne, agreed to join forces on this project and I am grateful to him for his efforts in photographing many pieces which he located in his position as Art Director for the Rochester, New York, Public Schools. He also developed and enlarged many of my photos in a manner which has enhanced the efforts of an amateur photographer. His part in the numerous activities in which co-authors need to combine endeavors is sincerely appreciated.

Grateful thanks are due to the many artists and museums who provided photos and granted permission for reproduction. We are appreciative also of the

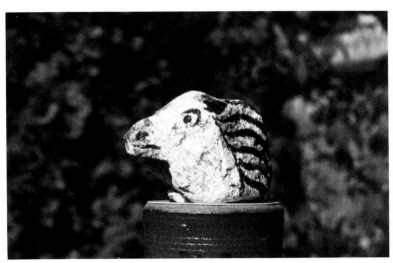

A stone shaped like a horse head prompted the addition of a few painted details.

willingness of many art teachers who submitted photos of their students' work . . . and often at considerable effort and expense to themselves.

Acknowledgment for individual pieces is indicated either with the photo or in the list of credits at the end of this book. Any credit omissions are due to accidental oversight or insufficient information on the source of material.

Each photo is accompanied by an explanation of materials used, the process of development, the means of attaching parts, and the necessary details for creating projects of that type and with similar materials, when such information is not visibly evident. Except for the occasional use of paint, adhesive or fastening materials, there are few pieces illustrated in which commercial art supplies have been used.

The photographed works have been created by a range of ages from the very young to the mature, professional artist.

Carl Reed
University of Massachusetts
January 3, 1974

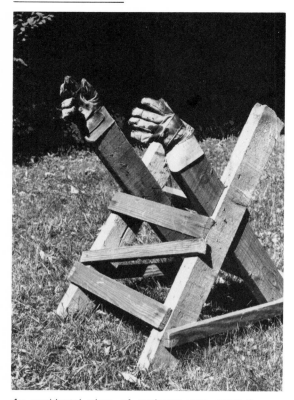

An accidental piece of sculpture was created when a workman placed his gloves on the ends of a sawhorse. The artist who photographed the piece called it Supplication.

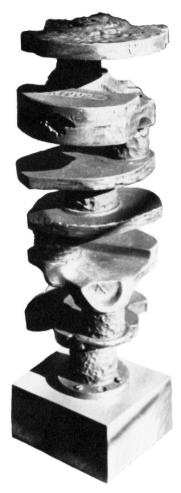

When a sculptor found this camshaft, he felt it needed only a few changes to complete a finished sculpture. An acetylene torch was used to burn a few holes, texture some smooth surfaces, and to soften edges. Nothing was added to the metal before mounting it on a wood base — ready for exhibition!

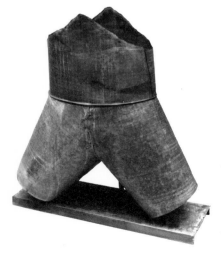

John W. Dowe, Jr. found a section of an air duct. It appeared to him as a sculptured "Torso" ready for mounting. (Dowe considers himself a layman and not a sculptor.) Entered in a major, juried exhibition this piece was awarded the "best in show." Photo courtesy of The Memorial Art Gallery of the University of Rochester.

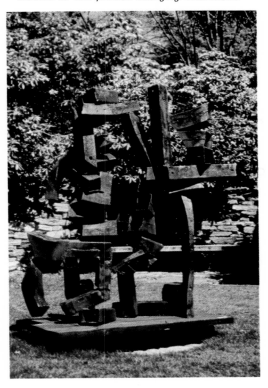

"Frames" by Sid Poritz. Welded auto frame allowed to rust provide changing colorations.

Section I

INTRODUCTION

The mature artist has had extensive experience working with various tools and materials and has become familiar with their limitations and possibilities. Thus, he has confidence in his ability to manipulate them. He also has developed the habit of gathering diverse ideas and accumulating them as resource material. So, when his is inspired to create . . . by an emotional experience, a situation, a medium or an object . . . there is hardly a conceivable factor that can interfere with his "go" process.

However, the average person often feels quite inadequate, when confronted by a virgin sheet of paper on which to draw or paint, or a void in which to sculpt or construct. This challenge and insecurity usually results in what is interpreted as lack of interest in creativity. More than likely, the feeling of inadequacy, as related to creative ability, is

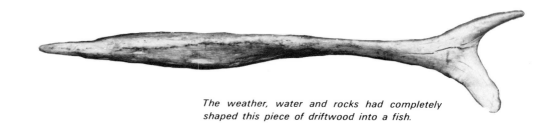

The weather, water and rocks had completely shaped this piece of driftwood into a fish.

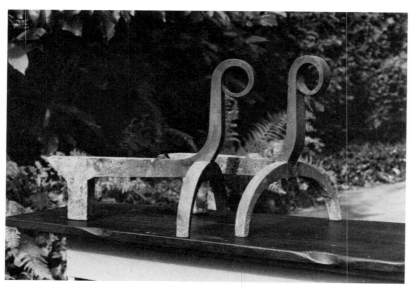

In colonial days fireplace andirons were called "fire dogs." This pair of antique andirons appeared to be such a sophisticated, contemporary interpretation of dogs that they were mounted, without alteration, as an outdoor sculpture.

A muffler, fallen from a passing car, was battered by traffic into this shape suggesting something like a blow fish or a pig. The perceptive person can find objects everywhere which need little or no additions or reshaping in order to become attractive sculptural pieces.

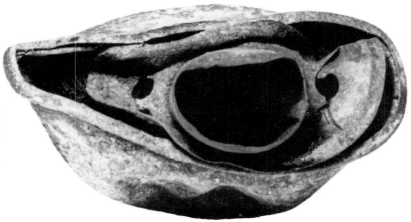

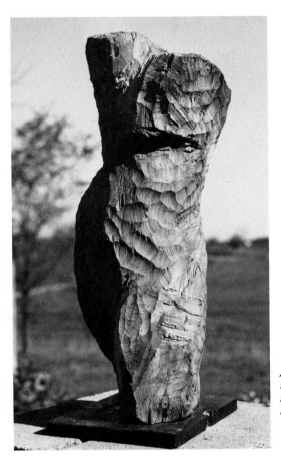

A section of a tree suggested this "Elm Torso" to the artist David Hysell. The partially finished piece still shows the formation of the trunk and branches which suggested the final design.

more a frame of mind than an actuality. Often the same persons who feel that they are lacking in creative ability will see a cloud or rock and exclaim: "That looks like a man!" or "There is a bear." (It may well be that this same sort of stimulus is what motivated the earliest known artists in their cave paintings.)

When provided with a form such as a container or an interestingly shaped found object, or a central structure on which to build, the hesitant amateur is able to overcome the initial hurdle of nothingness or emptiness. Imaginative images take shape and creative ideas stimulate the mind and hand.

This type of initial motivation or inspiration has occurred to each of us who has ever rolled up a ball of clay or snow, with no particular aim in mind. After the first ball had been

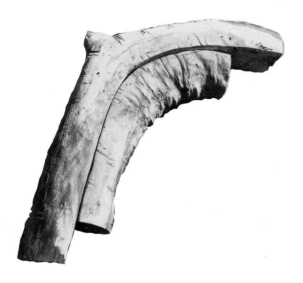

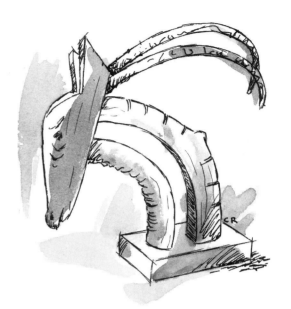

The twisted maple branch with the rippled texture appeared to be like the neck of an animal with wrinkled skin. This motivated the modeling of an ibex which was first sketched. Then horns were selected from curved pine branches, and a head was fashioned from a walnut beam.

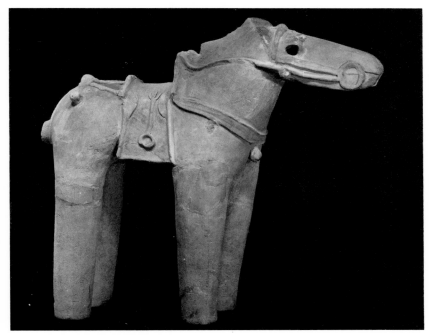

Haniwa horse, earthenware, Japanese 3rd-6th century. This piece is partly restored. The ears, mane, tail, and parts of the saddle and harness decorations are missing. Haniwa means clay cylinders. These simple tubular forms were later used by potters to create sculptural figures. In the photo the four legs of the horse were made from such cylinders. In the sketch of the Haniwa woman the skirt was formed with a cylinder. Sculpture from containers! Photo courtesy of the Seattle Art Museum, Eygene Fuller Memorial Collection.

completed it seemed to call for another. When these were piled on top of each other . . . if the material happened to be snow . . . we had a symbolic human figure in snow. With the addition of a few sticks, stones, and a hat or scarf, we had "mother", or "father", or an "old man", or a "witch".

For the young artist to develop a three-dimensional composition after he has been motivated by some unusual shape, and when he has a solid form on which to build, he is more likely to be interested and successful than if a teacher were to provide a supply of some raw material and say: "Let's all sculpt a man."

Containers and found objects may be used in exercises to stimulate creative thinking. A teacher might hold up a plastic cup, and, after making two small black dots on it,

The horn provided not only a practical, natural container, but also a graceful form in which colonial men carried their gunpowder. This powder horn, dated 1703, is decorated with an engraved scene of New York City, animals, and the emblem of the English Order of the Bath. Gift of Isabel Herdle to the Memorial Art Gallery of the University of Rochester.

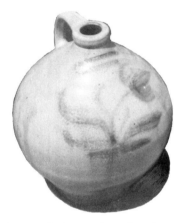

A sturdy ceramic jug made at Bennington, Vermont. This gracefully shaped jug is decorated with a blue slip flower design. When empty these jugs were brought back to the vender to be refilled with molasses, syrup, vinegar. etc.

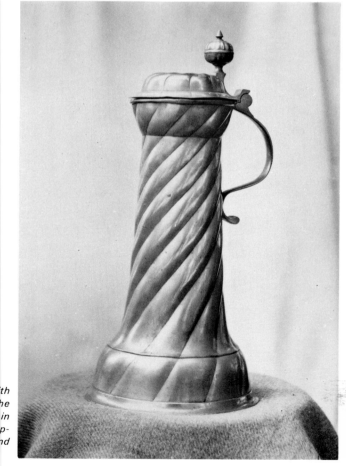

A beautifully crafted, antique pewter mug with great emphasis on sculptural quality. The Rhineland craftsman proudly stamped his mark in the bottom of the mug. The owner continually appreciates the piece both for its beautiful form and its practicality.

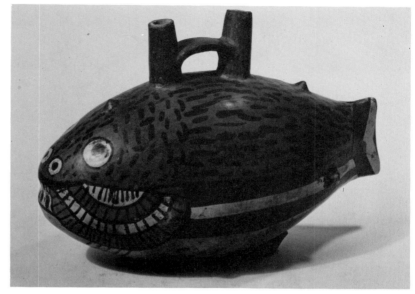

A 6th century Peruvian Pot in the form of a fish. Most cultures have produced sculptured containers in the form of animals, birds, fish, and man. The Minneapolis Institute of Arts.

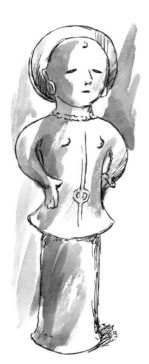

Haniwa woman.

ask: "Now what does this suggest to you?" Answers will fly back: "a clown", "a ladybug", "an owl", etc. Thus students begin to see the possibilities that are inherent in any ordinary object such as a disposable cup. With the imagination aroused, all objects become items for consideration and analysis, as possible sculpture materials and motivational elements.

Another approach might be to distribute supplies of wood scraps or various shaped containers to students and throw out the challenge of combining several pieces into a creative construction. The teacher should encourage students to explore, reshape, cut, join and paint various pieces.

Of course, a more effective procedure of making use of containers and found objects for sculpture in a school art

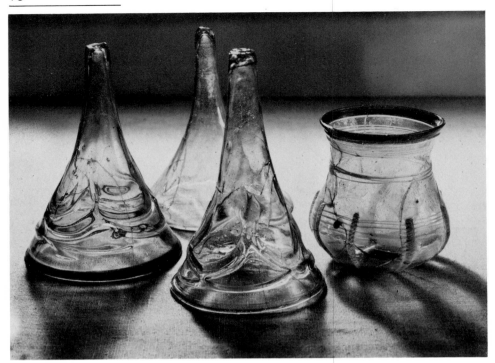

The earliest glass makers in Sweden were concerned with containers of aesthetic design and surface decorations. Historiska Museet, Stockholm. Foto ATA.

program would be to encourage students to search out and bring to class a variety of items, and encourage each student to make his own selection with which to create the structures that inspire or motivate him at that time; correlating his materials with his own imagination, background, and experiences . . . the student's own expression. Seeking out interesting forms and textures develops the individual's perception and awareness of his environment.

Materials for appreciation and use in sculpture are almost endless. They may be found in the woods, the desert, on beaches, in attics, cellars, secondhand shops, in towns and cities, in trash cans and on dumps. There is no shortage of sculpture material.

Disposable containers of a multitude of shapes and compositions are a rather unique development of our pre-

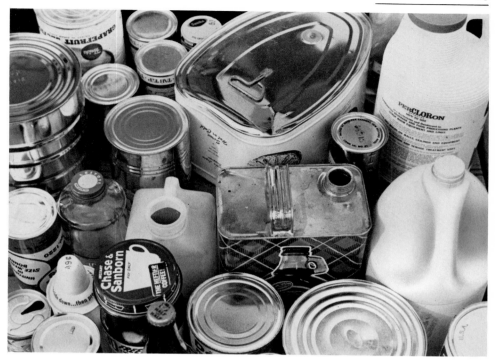

Plastic, metal and glass containers of a wide range are readily available to the sculptor.

sent culture. These containers are made of glass, plastic, fiber glass, Styrofoam, wood, raffia, pressboard, cardboard, aluminum, tin, steel, copper and other material. The shapes are even more varied than are the materials. The containers are practical, light, handy, non-breakable, easy to carry and easy to open. While numerous containers are without distinction in design, many are attractively shaped. The containers are not intended for reuse and some are actually labeled: "Not to be refilled." In any event, most of them end up on the rubbish heap, soon after the contents are consumed.

Throughout most of history man has made and used containers that were created with some attempt at aesthetic qualities. Archeologists continue to find evidence that the most primitive peoples from prehistoric periods produced attractively designed and decorative

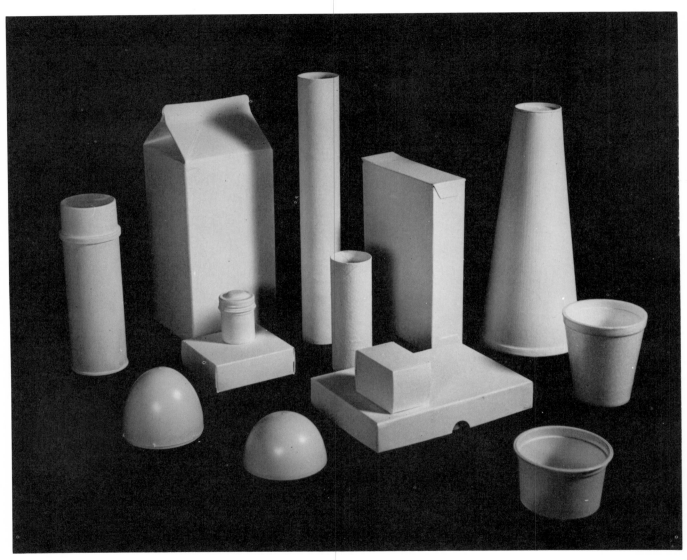

Commercial containers, when all color has been covered, emphasize the variety of basic forms.

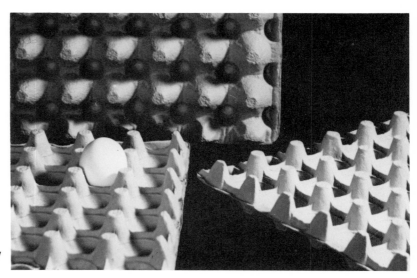

The egg carton offers a variety of interesting patterns — both on the inside and the outside.

receptacles of clay, fibers, wood and stone. Many of the beautifully sculptured and painted containers of the early Greeks, intended originally for such practical purposes as holding grain, water or wine have eventually become enormously high-priced museum pieces. Interest in a beautiful form was also a concern of the American Indian in his basketry and pottery. In colonial United States some beautiful jugs and bottles were fabricated, which were used, preserved, and reused, over and over again. Following the handcraft period in this country, the majority of containers manufactured were round tin cans, rectilinear boxes or bottles of quite ordinary and common form. Ease of manufacture with the cheapest available materials was the primary concern, rather than an attractive and unique shape.

22

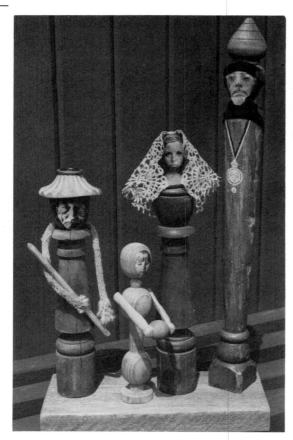

"Generation Gap." Old stair railings, rope, lace, velvet and photos were used by Sarah Stephens, Bloomington, Ill. High School. Elizabeth Stein art teacher. [This photo and all other photos used by courtesy of "School Arts Magazine" will carry an asterisk at the end of the caption but no footnote, since recognition is given in the credits' section.]*

With cosmetic containers as notable exceptions, most containers were made without any attempt at aesthetic quality . . . a bottle was a bottle and a box was a box. Then, with the advent of plastic materials, a real revolution took place in container designs, and now, almost daily, we find a new container form on the supermarket shelves. While most containers are designed primarily for their practicality, many have attractive and distinctive sculptural qualities. These containers, instead of going to the junk heap, can provide a free source of basic sculptural forms and materials. Some even suggest realistically sculptured forms. Many plastic cosmetic and detergent containers suggest a feminine form, or tops of egg cartons may suggest pairs of protruding animal eyes. For anyone with aesthetic responsiveness, it would seem impossible to look at an open carton of eggs and not appreciate the smooth, symmetrical form of the dozen eggs set in

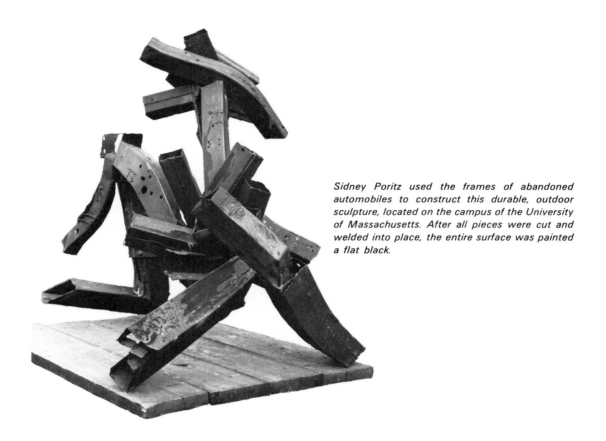

Sidney Poritz used the frames of abandoned automobiles to construct this durable, outdoor sculpture, located on the campus of the University of Massachusetts. After all pieces were cut and welded into place, the entire surface was painted a flat black.

provide an almost endless supply of "raw material" for sculpture in metal, wood and plastic forms originally shaped by machines in mass production. One abandoned automobile provides hundreds of pieces of metal and plastic forms ready for combining or reshaping into sculpture. A discarded clock can be a rich supply of wheels and gears for use in smaller creations. Abandoned furniture is a source for ready-made turned pieces of wood which can save many hours of shaping by the artist. The heating element from the oven of an electric stove provide the base for a woven sculpture, illustrated in the text. Another woven sculpture incorporated the grids from the top of the gas range. A single trip to a metal junk yard or a city dump can supply an artist with enough materials for months of work.

The shape, color, and texture of many plastic containers suggest a variety of sculptural forms.

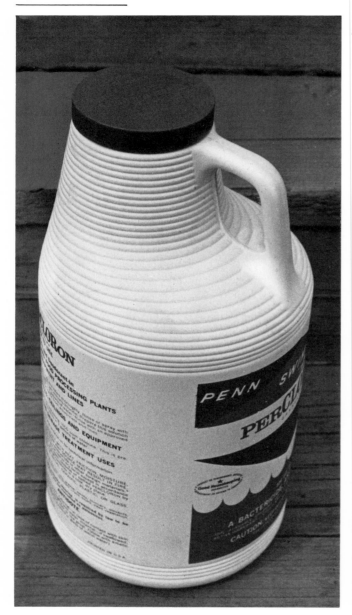

The form of this container offered a challenge.

When two identical containers were placed back to back, a design began to take shape and the finished sculpture was readily envisioned.

Section II

PLASTIC CONTAINERS

With the advent of plastics it became possible to design disposable containers in a wide range of shapes. These containers come in transparent, translucent and opaque materials; they are square, round, amorphic, smooth, ribbed, clear, white, colored and perforated.

The extensive range of forms tend to stimulate young artists' imaginations, and all sorts of animal and bird life begin to take shape in their minds, which are easily developed from the original motivating shapes. Mature artists also find inspiration from plastic containers.

In addition to the motivation, and the abundance and variety of such containers, there are many other advantages in their use. Of primary importance for the very young artist, thin plastic can be cut and shaped easily. Yet the material is sturdy enough to hold its form, even when

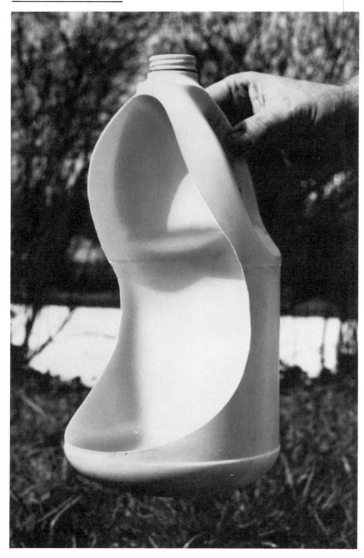

Scissors were used to cut similar patterns from two containers.

joined with other pieces and used to build rather large structures. Finished pieces are also waterproof and can survive long periods of exposure to weather.

Joining together parts of plastic sculptures is easily accomplished. A stapler readily fastens two or three thicknesses of the material. Most of the available adhesive cements are effective. Polymer emulsion and tissue paper may be used in a papier-mâché-like technique for joining parts and for filling in low spots, building additional forms, and for covering or creating surface textures. A torch is

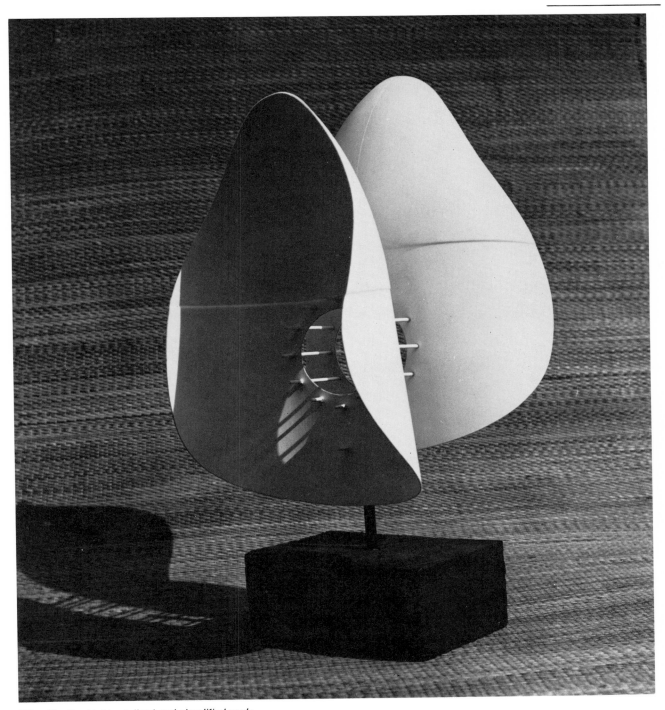

"The Kiss," a highly stylized and simplified sculp-
ture, which hardly indicates the origin of the forms
or material. Swab sticks in a circular pattern join
the two plastic pieces. Two of these sticks extend
through a vertical dowel which joins the base and
sculpture. Carl Reed.

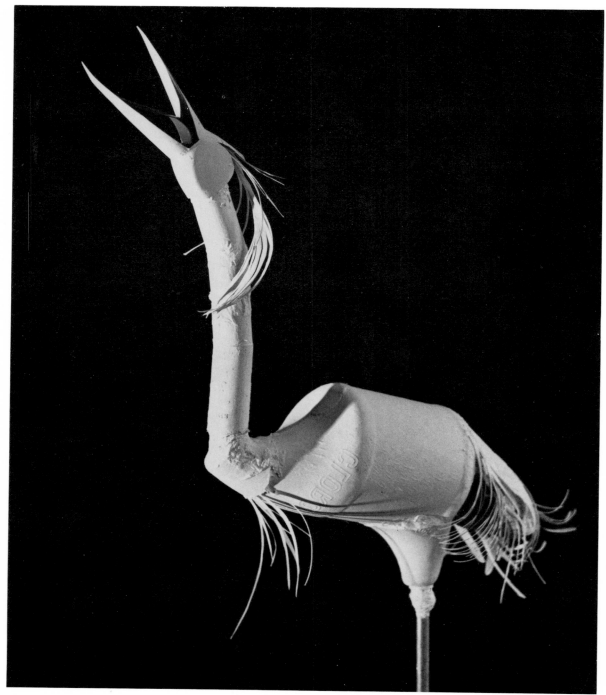

"Bird Call" by Marie Van Orden. Clorox bottles and mailing tubes are joined together with papier-mâché paste of tissue paper and polymer emulsion. Mounted on a wooden pole, with a weighted section of a bottle for a base, this white sculpture stands five feet high.

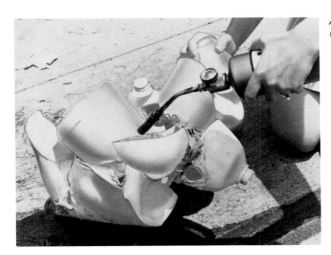

A Bernzomatic torch can be used to cut, mold, and weld plastic materials.

This sculpture was formed with a combination of whole and cut containers. Parts are joined by insertion, heat welding and papier-mâché putty. Wisconsin State University.

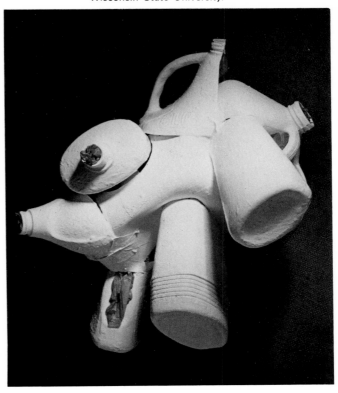

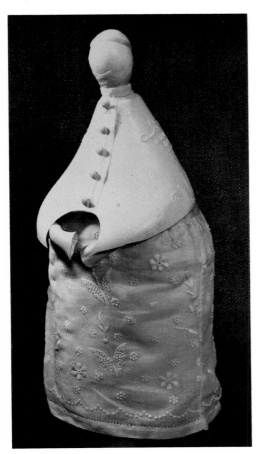

"The Bishop," constructed in Haniwa fashion, with a plastic cylinder used for a body. A flash bulb covered with papier-mâché serves as a head. Marie Van Orden.

useful for cutting, molding and joining together sections of plastic containers. However, as plastic melts very easily, it is not always possible to control shapes as desired.

Because plastic is non-porous, finished sculptures may be readily painted with one coat of brush or spray paint.

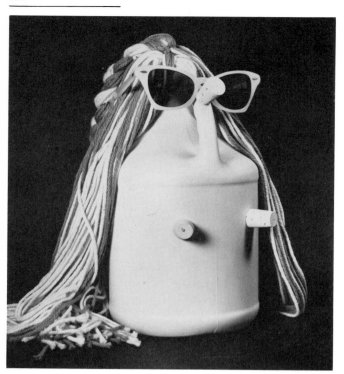

All materials in this cleverly arranged figure are evident. Dark glasses and colorful yarns gave accent to the piece. East High School student, Rochester, N.Y.

Plastic berry baskets were joined together by an extended "Slinkey." Completed in a workshop conducted by Carl Reed at Wisconsin State University.

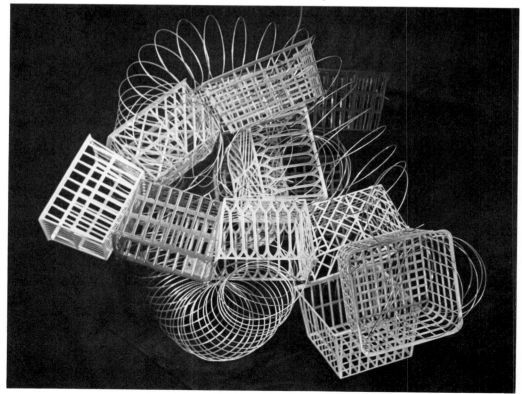

Both transparent and opaque white plastic bottles were used to fashion this bird. Marie Van Orden.

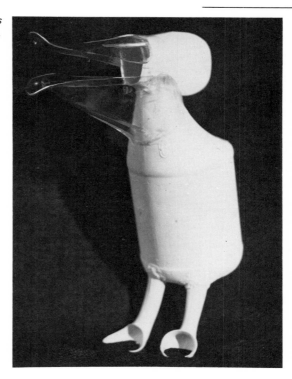

A fearsome plastic bird created by teacher-artist Marie Van Orden.

An artist, who creates with found objects, gathering materials from a beach which might appear to be barren to a less perceptive person.

"The Family" by a graphic artist, just before it was erased by the incoming tide.

"The Mermaid" with a sculptured sand body, shell scales, seaweed hair, and a tail of kelp.

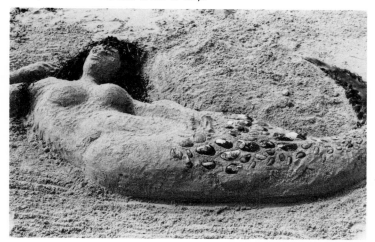

Section III

SAND AND BEACH

The beach, for millions of people, is primarily a place for sun bathing, swimming and picnicking. For the artist, the beach can be the most inspiring, exciting and satisfying location in the world. He can approach this area without any tools or art materials, and there he can find all the necessary items with which to construct innumerable sculptures, for days on end. In addition, the sculptor has a free studio in which to create and he can work in the invigorating outdoor atmosphere, while enjoying the sun and surf.

The flotsam and jetsam found on beaches have long been a part of our lore and literature. These objects can supply an abundance of materials for sculpture. In addition, there are the numerous articles discarded from

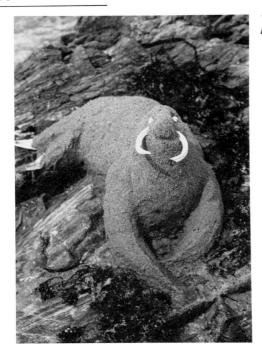

"Walrus," with plastic tusks and eyes of white beach pebbles.

A five-year-old boy hastily created his interpretation of a mermaid's head after watching "The Mermaid" being shaped by an adult.

Wall sculpture and mirror frame formed by sand casting. William Barry.

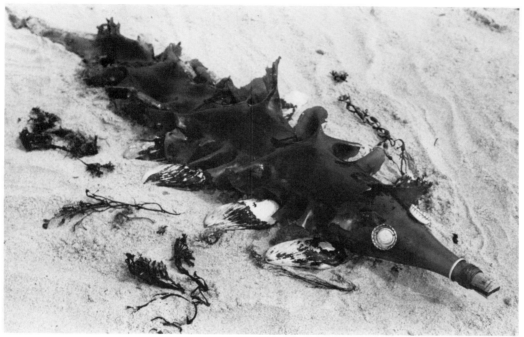

A long, translucent, amber colored piece of kelp (laminaria) was easily made into a formidable land-sea monster by adding a bottle, two bottle caps and a few shells. The bottle's similarity in color, surface texture, and translucency made it difficult to distinguish glass from kelp. Two small bits of chewing gum attached the eyes.

fishing and pleasure boats and by the thousands of people who frequent the beaches. There is also the unlimited supply of wet sand, shells, stones and varieties of seaweed with which to compose and sculpt. (There are about 100,000 species of seaweed or algae . . . with the giant kelp of the Pacific growing to several hundred feet in length.)

Then there is the never ending supply of driftwood . . . both sawn pieces and natural ones . . . in the various shapes and states of erosion. Many sections of driftwood are of exciting forms ready to be mounted as is; with their shapes softly contoured by the pounding waves, rocks and sand and their surfaces a delightful, silvery gray resulting from exposure to water, salt and sun.

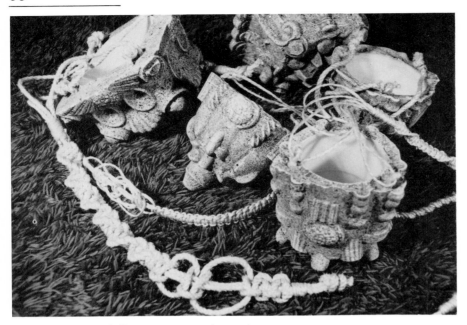

Hanging, sculptured flower pots cast in sand.
Pieces of furniture and other found objects used in
mold making. William Barry, artist-teacher,
Rochester, N.Y. City Schools.

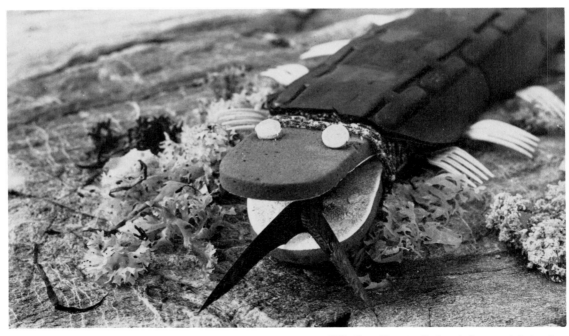

"Flip-flop Monster." A net from a lobster trap
holds the folded beach sandal head.

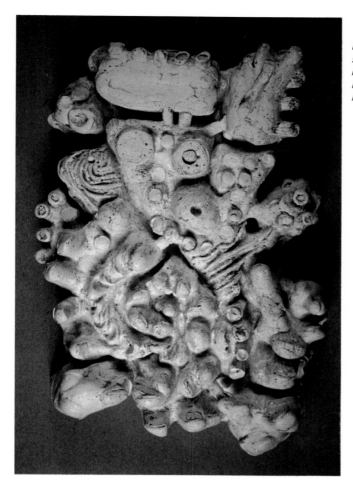

Plaster cast. Found objects punched into clay and sand in the mold construction. Strong resemblance to clay sculptures of 6th century Mexico. Diane Halvey, University of Massachusetts workshop.

The wet sand suffices as a complete sculptural material . . . although the finished pieces may be of a transitory nature. Sand can also serve as a binding material for solid objects found along the shore. The solid beach provides a firm base into which rigid objects can be placed for erecting various compositions. The many shaped containers scattered about by picnickers serve as molds for shaping wet sand. There is always an ample supply of water for use in maintaining sand in a wet modeling state, or to erode parts of a sculptural form with pleasant textural effects. (Such pieces are shown in this section.)

It would be difficult to locate another place on earth where one could find such a wide range of natural and man made materials as can be collected along a short stretch of beach.

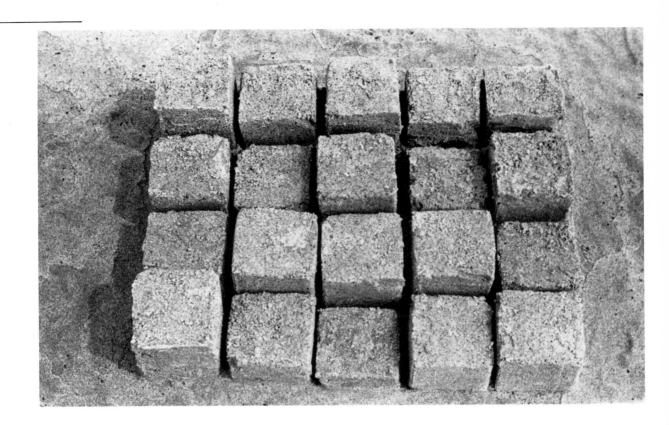

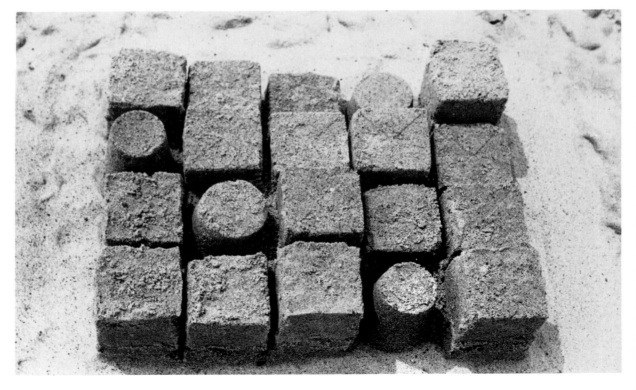

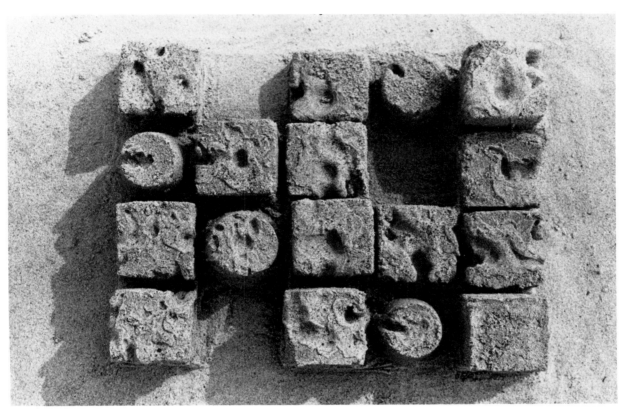

Three modifications of one sand sculpture made with milk cartons and round ice cream containers.

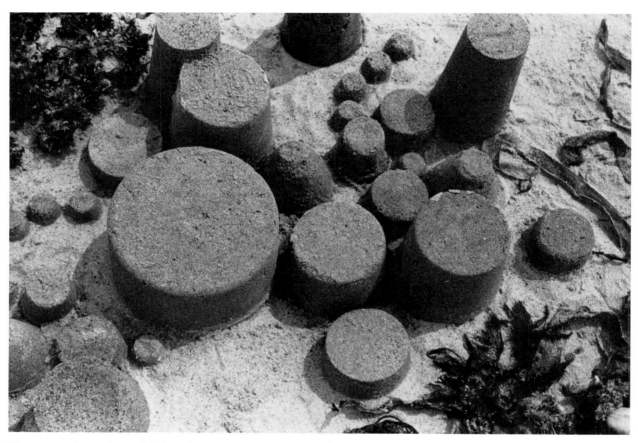

Diverse round containers picked up in one small area of beach motivated this sculpture of curvilinear forms.

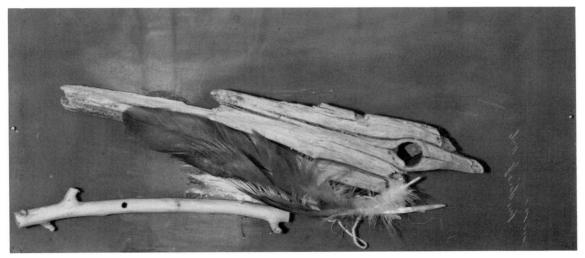

"Seabird." Two pieces of driftwood, gull's feathers and fragment of ancient glass mounted on canvas. Photo courtesy of the artist, Donald Reichert.

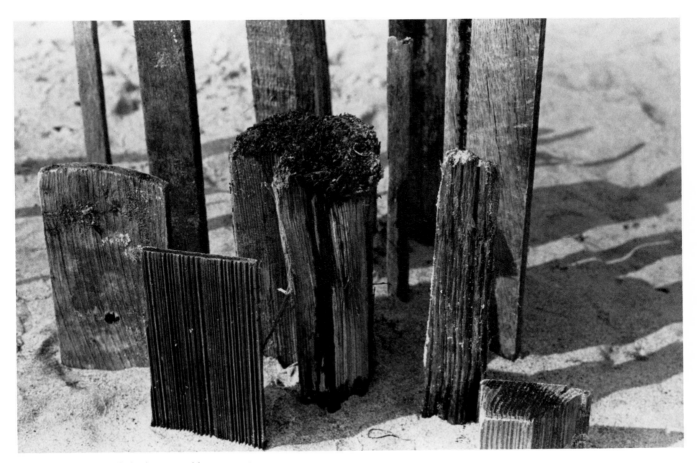

Wood, sand, sun, and shadows combine to create an interesting pattern of texture, space, and tones.

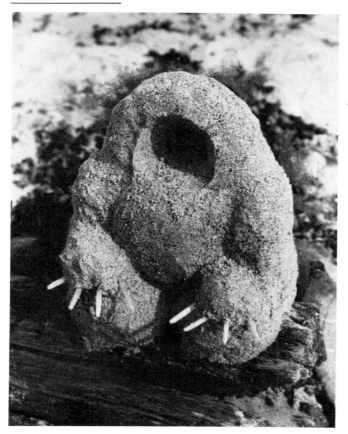

"Inscrutable," by Brita. Sand, log, and quills from a seagull.

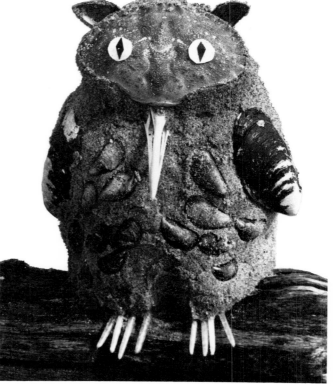

"An Owl," with all materials provided by nature, except the eyes which were bits of plastic. Photo and sculpture by Carl Reed.

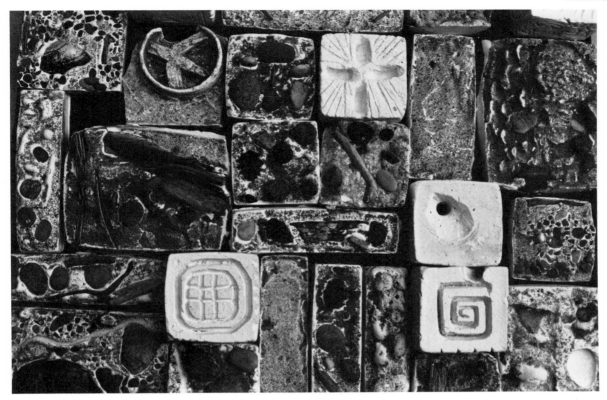

Eight graders completed this group wall sculpture. Each student did a casting in a separate box, using sand, pebbles, driftwood, shells, metal and plaster. Dan Kelleher, art teacher, Roosevelt Junior High School, Erie, Pa. *

For those imaginative souls who like to let their minds engage in speculation, it is interesting to try to determine the itinerary of various unusual objects that wash up on a beach. In numerous instances these objects must be many miles away from their origins or intended locations.

While structures of wet sand disintegrate rapidly in the sun, this sand can be mixed with cement or plaster to make durable structures. The sand can also serve to make molds into which concrete or plaster can be poured; many items can be combined in this process. In addition, selections from the multitude of articles found on the beach can be brought to an indoor studio for arrangement into permanent compositions. An enduring record of evanescent sand sculptures may be made on film, such as was done in many instances to illustrate this section.

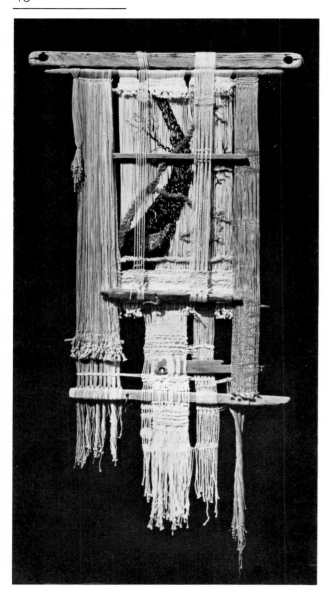

"Window." Worn pieces of wood formed the loom and became part of the wall sculpture. Scantily woven sections and tied off tassels suggest lace curtains. Tapestry weaving suggests the outdoor trees.

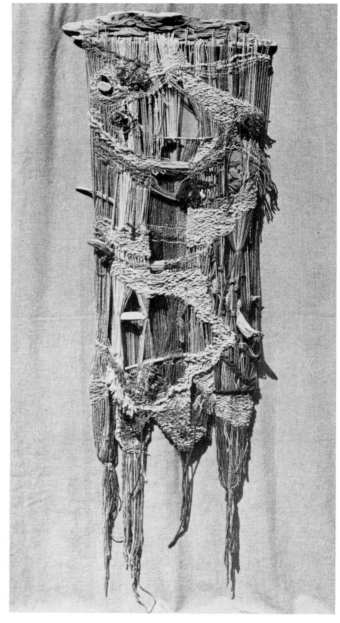

"Driftwood." Wormholes in the wood made it possible to warp the loom for a woven sculpture including several pieces of driftwood. Waves are suggested by the color of the yarns and the shapes of the pattern. The warp appears like water flowing over wood. Brita.

"Inside Outside" *by Brita. Caged stones and turned wood of an old spinning wheel hang inside the woven form.*

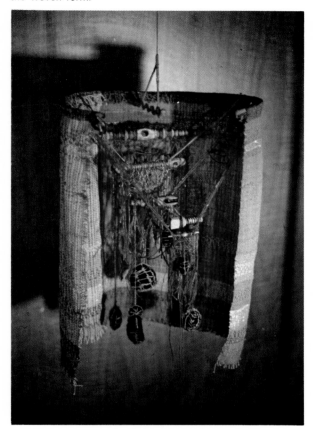

Section IV

THREAD, YARN AND FABRIC

Collecting found objects and incorporating them into woven sculpture often provokes the artist into a consciousness of, and an intimacy with, his environment. The greater breadth of materials presents the opportunities to do so more than any other type of activity in the plastic and visual arts.

Weaving throughout the centuries has been, almost entirely, a process of making fabrics. Except for the slight variations in textures developed by various yarns and patterns of weaving these fabrics have been relatively smooth and non-sculptured materials. (Basketry of reeds and grasses is one notable exception of the use of weaving to construct three-dimensional forms.) However, contemporary artists have broken the bonds of traditional

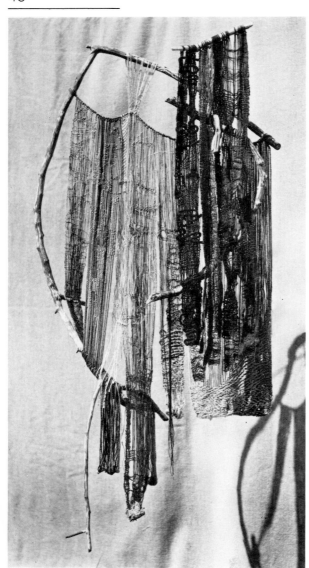

"Berkeley Farm Rosewood." An attractive free hanging sculpture hand woven on a frame of old rosewood pieces.

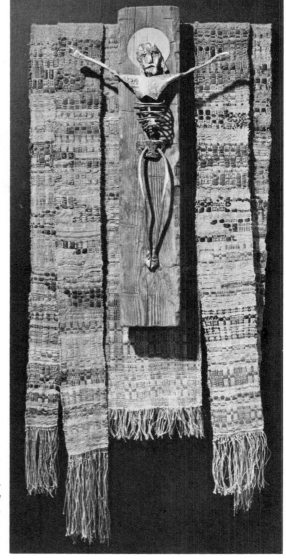

"The Stole." A master weaver blended fabric with wood in this sculpture from found objects. The Christ is made from square and round brass rods, scraps of sheet brass and heavy gauge, copper electric wire. The hands and feet are hammered brass casings from 30 caliber rifle shells. The figure is mounted on a hand-hewn timber. Sculpture by Carl Reed. Photo courtesy Springfield Daily News.

"Owl," 1970. Wool woven by loom and by hand. A beautifully colored weaving of blues and purples. The eyes done in a braid-like technique are about the size of a chair seat which indicates the huge proportions of the whole piece. Edita Vignere, Latvia, USSR. Courtesy of Museum of Fine Arts, Boston.

crafts and are creating woven pieces that range from mobiles to low relief sculptures, from freestanding forms to high relief wall hangings. Structures in thread, wire, yarn, plastic and fibers are also being fabricated. Using rigid objects such as crates, metal forms or tree branches, the soft woven fabrics can be incorporated to create a variety of sturdy forms. Commercially woven fabrics may be soaked in plastics and shaped into permanent objects of any desired contours. Pieces may be slowly assembled, weaving some portions, adding ready-made

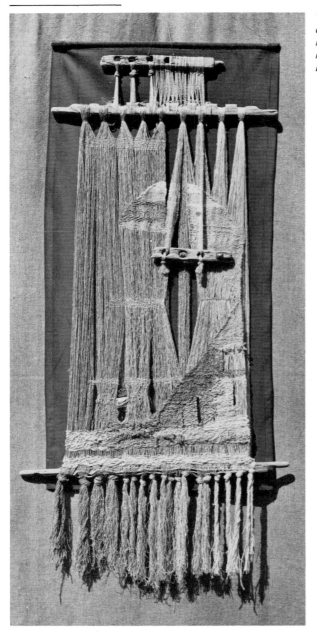

"Hampton Beach." Pieces of lobster traps found on the beach provided a warping frame for homespun linen which is graded in tones from natural cream color to deeply dyed brown. Woven by Brita.

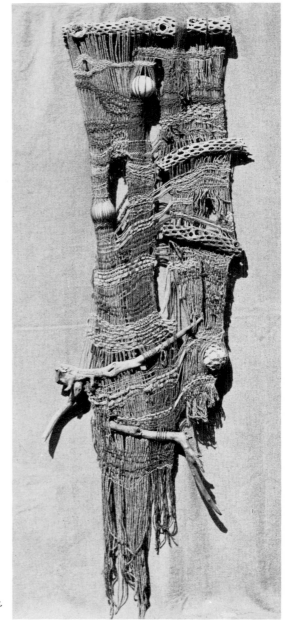

"Cactus." Yarn combines cholla cactus skeletons, weathered wood, and round desert gourds.

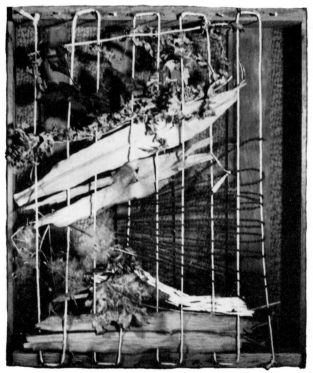

"Fall," by Barbara Davis. A fruit crate frame, leaves, yarn, twine and corn husks. University of Massachusetts workshop.

fabrics and a variety of found objects and, finally, coating the assemblage with fiber glass, in order to make a permanent, solid sculpture. The extensive range of hues, values and intensities in fabrics, yarns and found objects gives the sculptor in weaving as wide a palette as any painter ever enjoyed.

Using found objects such as driftwood or tree branches as the basis of a primitive loom, not only suggests a variety of forms for the woven piece, but also frees the novice weaver from the limitations often felt when one uses a commercially made harness loom. Being at liberty to build designs on an unconventional, free-form loom makes it easier for the artist to identify with the textures, colors and natural qualities of fibers and to experiment with various

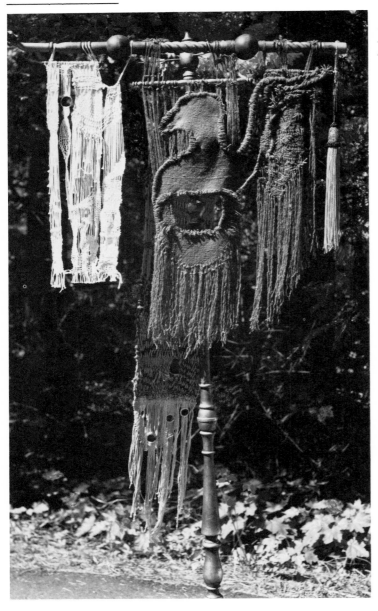

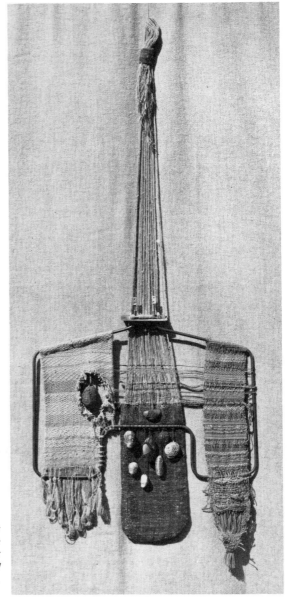

"Dicite." The brass eagle claw on a piano stool leg inspired this red, white and blue freestanding sculpture. The base and upright is part of an old floor lamp.

"Oven." The heating element from an electric stove motivated the composition and provided the framework. Brilliant orange on black yarns suggest sparks, flames and hot electric elements. Natural stones, caged in yarns, accent the formal weaving. Sculpture by Brita.

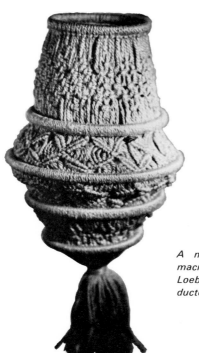

A monochromatic hanging sculpture. Yarn, macramé and embroidery rings. Artist, Tracey Loeb, University of Massachusetts workshop conducted by Nancy Smith.

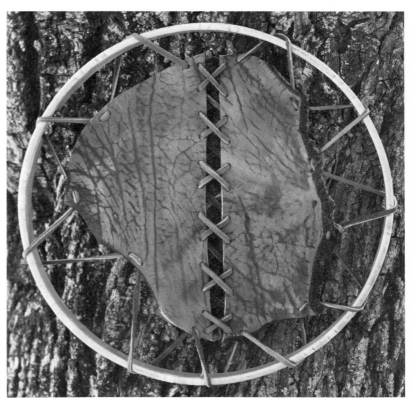

"Drumhead." Scrap leather, snare drum head, frame of wood and leather thongs. The Groton School, Groton, Mass.

"Orange Monolith." A weaver's soft sculpture interpretation of an ink and colored wash drawing. The loom woven pieces are stuffed with cotton and combined with soft black iron wire.

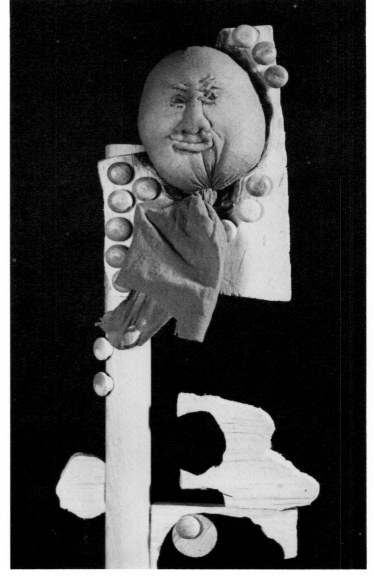

A stuffed and stitched stocking, a knothole in a board, turned wooden drawer pulls and irregularly cut wood scraps were combined by an elementary school child to create a fascinating sculpture. Elementary School #27, Rochester, N.Y.

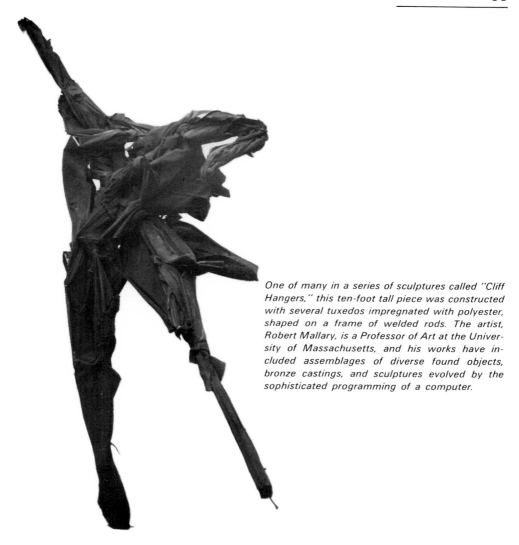

One of many in a series of sculptures called "Cliff Hangers," this ten-foot tall piece was constructed with several tuxedos impregnated with polyester, shaped on a frame of welded rods. The artist, Robert Mallary, is a Professor of Art at the University of Massachusetts, and his works have included assemblages of diverse found objects, bronze castings, and sculptures evolved by the sophisticated programming of a computer.

combination. Natural yarns of cotton, wool or linen may be combined in weaving with other natural materials such as grasses, pine needles, corn husks and rushes.

If we were to ignore all natural materials, there would still be an abundance of manufactured objects of wood, metal and plastics that could provide the basic materials for looms and which might be woven into geometrical or amorphic shaped sculptures with the numerous synthetic fibers.

The multitude of combinations of natural and man-made objects and fibers available for use in sculpture may stagger the imagination of all except the creative person.

"Primitive Mask." Mailing tubes, papier-mâché, spray paint and yarn. Rochester, N.Y. City Schools.

Section V

"Pregnant Woman." Form built of layers of cut, corrugated cardboard, covered with modeling paste and paint. Nancy Curvino, Fort Lee, N.J. High School. *

PAPER CUPS AND CARDBOARD CONTAINERS

For the mature sculptor who prefers to work with lightweight, easily shaped and readily colored materials; or for the youthful artist who cannot manipulate less tractable materials, paper cups and cardboard containers are one solution. These simple and easily acquired media are capable of being wrought into highly sophisticated and durable sculptures.

Enormous supplies of paper cups can be procured near any single cola dispensing machine or at most cafeterias and lunch counters. Collecting variations in cup shapes may require investigating several sources.

Any school or business office can be the source of a profusion of cardboard containers, mailing tubes, and

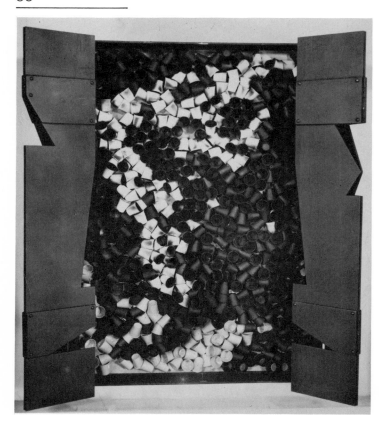

"Captive Ego." A study, bolted wood frame emphasizes the mass of delicate plastic cups. Artist, Fredric Karoly.

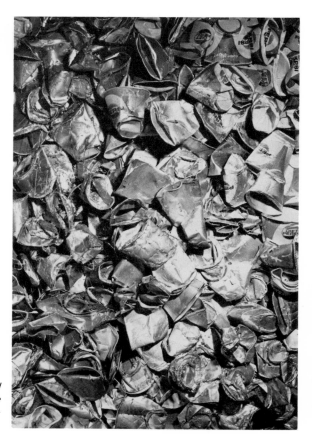

Wall sculpture composed entirely of crushed paper cups. Some areas are spray painted, while the gay colors of the unpainted cups provide accent notes. Phillips Andover Academy.

"Sculpture." Cardboard containers, modeling paste and spray paint, mounted on a wooden base. Linda Herman, Fort Lee High School.

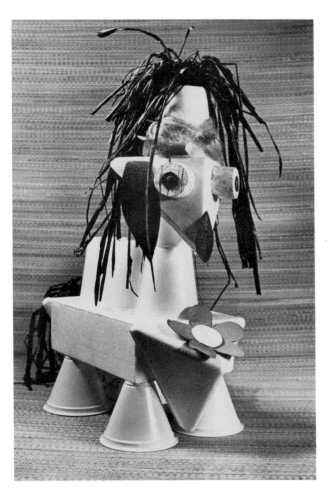

Styrofoam packing materials and plastic cups form this pert little dog with a top head and tail of raffia. Rochester City Schools.

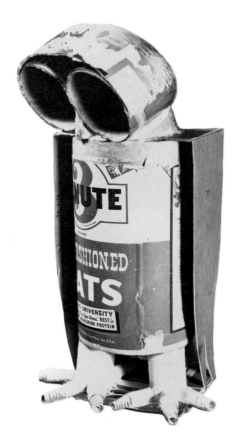

All materials used to compose this owl are readily distinguishable. Towne photo.

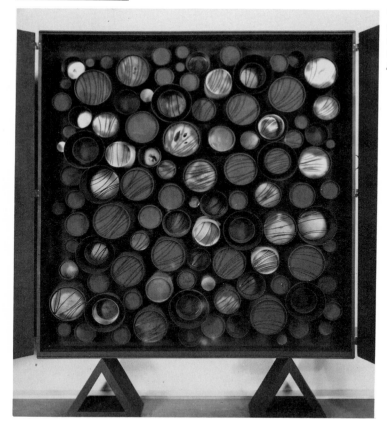

"Tabernacle." The rectilinear black box emphasizes the curved, interior forms of cardboard containers. A variety of surface decorations are arranged by strips of cord and different color paints. Fredric Karoly.

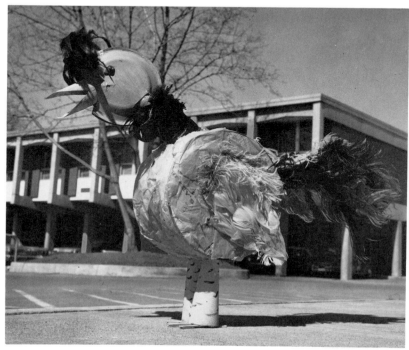

"The Rooster." A hat box, covered with tissue paper, forms the body, with the head made of two paper pie plates. Rochester City Schools.

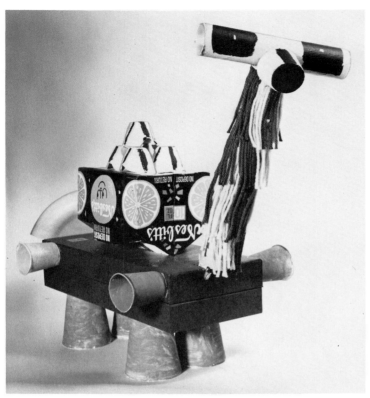

An upside down soft drink six pack is inserted into a box with a folding cover to form the body of this unusual animal. Mailing tubes, yarn, egg cartons, paper cups, and pie plates are combined in the composition.

varied packing materials. With access to the receiving room of a single drug or department store one could become innundated with a plethora of cardboard containers.

Cups and containers are especially well suited materials for works by young student artists. The enormous and relatively free source of supplies encourages experimentation with the media without the concern for waste which often imposes restrictions when costly art materials are used. Difficulties with shaping and constructing are minimized with easily cut and handled cups and containers. Pieces are readily joined and conveniently separated and replaced or rearranged. Joining of the light materials is simply accomplished with staples, string, wire, paper or masking tape, papier-mâché, model making cement or almost any fast drying adhesive.

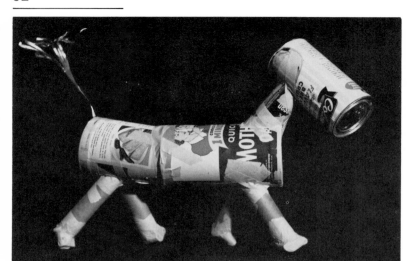

A dog with a tail cut from a tin can.

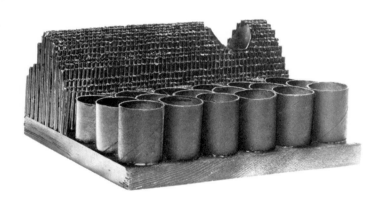

Mailing tubes and corrugated cardboard cut and combined with a wooden base. All materials left unpainted. Fort Lee High School.

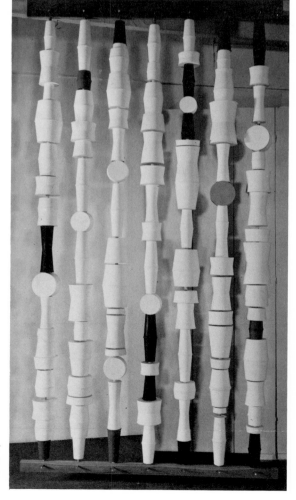

"Seven Poles." Assorted sizes of spools, paper cups, and paint buckets were assembled on long metal tubes in this hanging sculpture by Fredric Karoly. Walnut bars are at top and bottom.

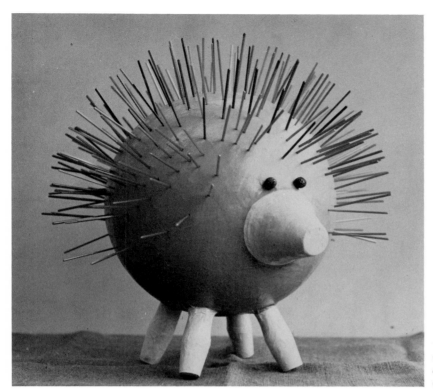

"Porcupine." Styrofoam ball provides the body which has swab stick "quills". From workshop conducted by Anthony Bonadies, Southern Connecticut State College.

Corrugated cardboard may be folded or cut and pasted to construct very large, light and sturdy structures. Cups, mailing tubes and other containers provide a light basic form on which to build with modeling paste or papier-mâché. Flat containers may be cut and built up in layers to form intricate shapes which would be difficult to carve in solid materials. Even durable outdoor sculptures have been constructed with a cardboard base covered with metal putty or fiber glass.

Large and rigid sculptures are possible when fragile cardboard containers are combined with a rigid wood or metal skeleton or frame.

Explorations with simple and easily obtained paper cups and cardboard containers can challenge the creative person . . . of any age level . . . for limitless hours. The variations in productions can be almost endless.

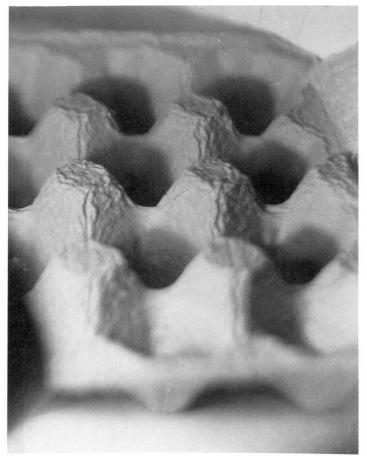

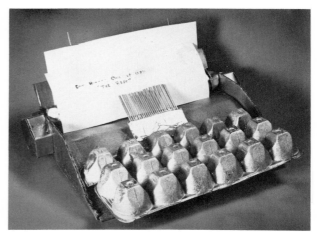

"The Best." Egg cartons transformed into a typewriter. East High School, Rochester, N.Y.

"Egg Box Craters." A high school photographer found an egg carton, interesting enough without any modifications, to make it the principal subject for a photograph. Eugene Beauchemin, Palmer, Mass. High School

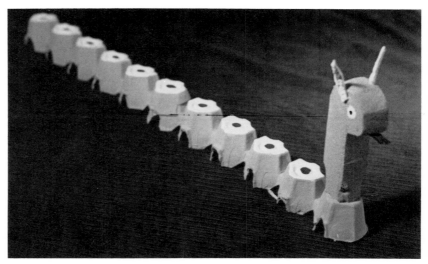

An innovative animal with a foam rubber head on a body of egg carton pieces.

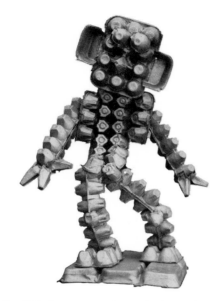

"Mutation." Various egg cartons wired together. The base was joined with masking tape. Arland Nelson, North Dakota School of Science. Mary Sand, art teacher.

Section VI

EGG CARTONS

Probably no single container or found object was more instrumental in the motivation of this book than the egg carton.

The egg has been described as the most perfectly designed package. The shell provides a sanitary covering for its contents, from initial production to ultimate use. If the egg has been fertilized, the shell permits an ample supply of oxygen during incubation and adequate shielding for the developing chick. Then, when the time is ripe, it is easily fractured by the delicate occupant allowing entrance into the outside world.

The egg shell is a visually satisfying form. (It is difficult to imagine a shape that would be better suited to the process of production or more comfortable for the

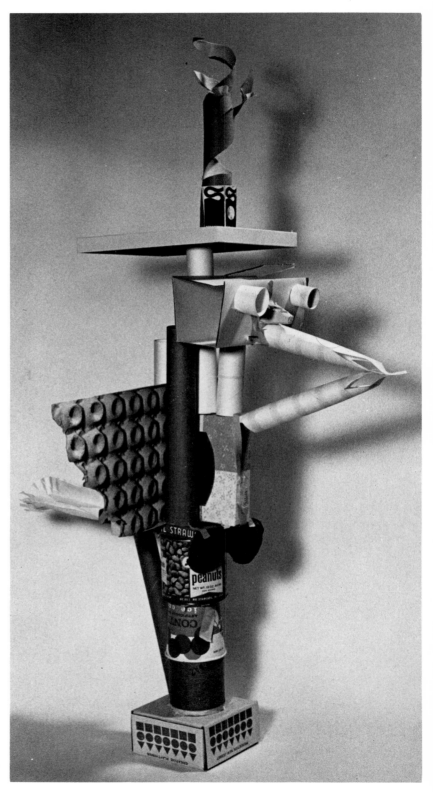

Egg cartons combined with several easily identified containers, to create a cardboard totem.

"Lemon Lamp." A combination of transluscent Styrofoam egg cartons. Ray Farrell.

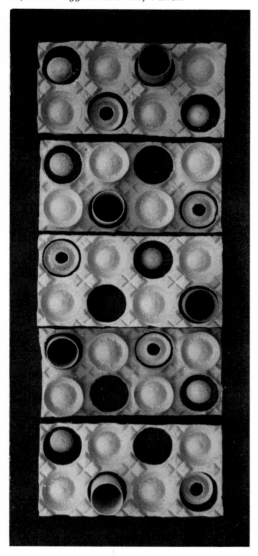

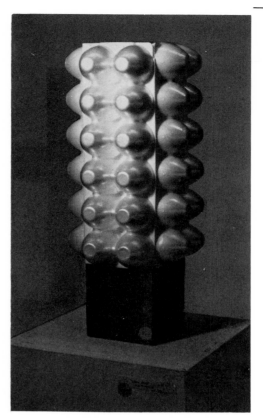

Sections of a fruit carton and mailing tubes were mounted at various levels and painted black and white in creating this bas-relief wall sculpture. Martha Wylie, Bloomington, Ill. High School.

manufacturer in production.) The egg was not designed for commercial handling, storing, shipping and distribution. Therefore, the egg carton becomes a necessity. The eggs and the carton make a pleasing combination which challenges any other product and package for aesthetic quality. The soft gray textured surface of the traditional egg carton, with its rows of smoothly contoured egg shells changes daily as eggs are removed. When all eggs are used, the empty gray, sculptured carton is still an attractive form, both inside and out and is a motivational piece, stimulating the observer to imagine eyes, heads, ears, noses, breasts, vertebrae, legs, typewriter keys, wings, turtle, bugs, etc.

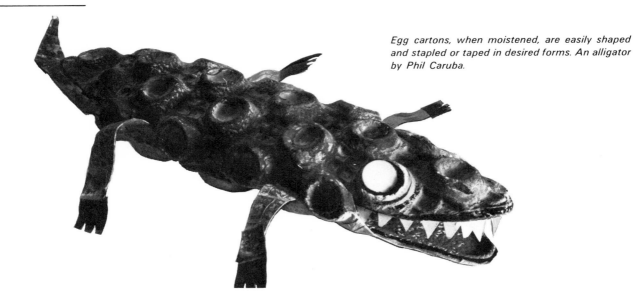

Egg cartons, when moistened, are easily shaped and stapled or taped in desired forms. An alligator by Phil Caruba.

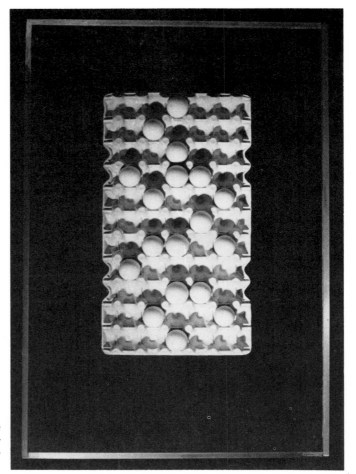

"A Dozen and a Half Large White." Blown eggs filled with polyurethane and fastened with epoxy in a double section of a commercial egg carton and framed with aluminum. Carl Reed.

Balsa wood sticks, cartons and corks, with some casual daubs of white tempera.

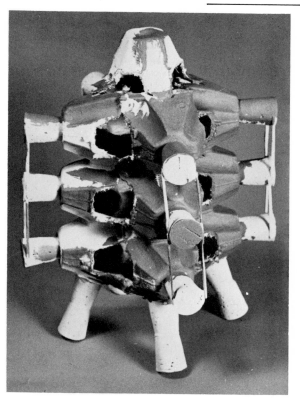

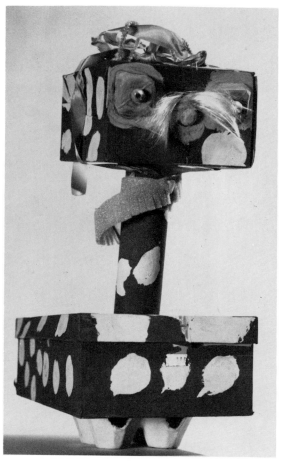

The components of this alert looking animal are readily discernible.

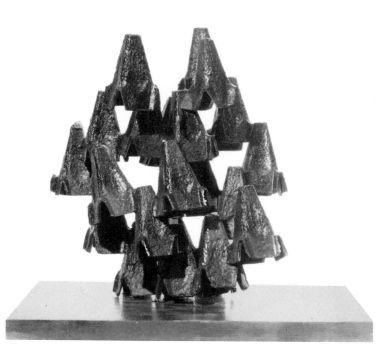

Sections of egg cartons interlocked and then coated with metallic spray paint. Fort Lee High School.

Egg cartons, wood strips and plastic straws. No paint was used and most parts were held together by friction. Wisconsin State University.

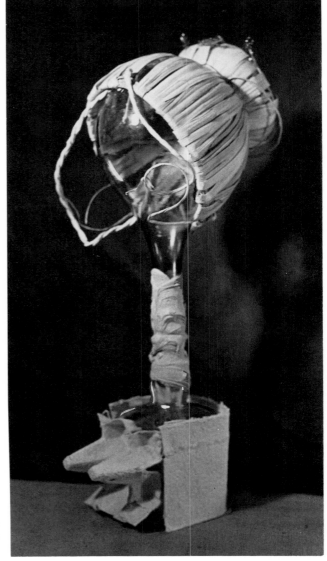

"Head and Shoulders." Two bottles joined together by plastic putty with shoulders and bosom of egg cartons.

"The Stadium." East High School, Rochester, N.Y.

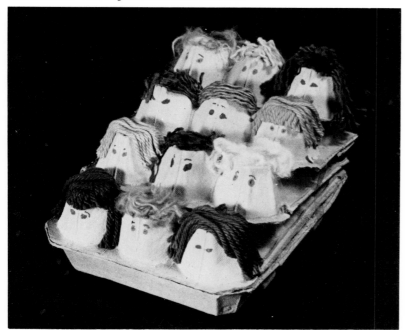

In recent years there has been a flood of plastic containers for eggs in a variety of shapes and colors, many of which have a very sensuous quality. These add to the many possibilities in the use of egg cartons for sculpture.

Though very light in weight and easily cut, egg cartons are unusually sturdy and can be joined together in constructing rather large, self-supporting sculptures. The cartons may be readily attached to other materials when a variety of objects are used. They are, easily painted when coloration is desired. Egg cartons come in a steady flow into most homes and it is not necessary to seek out a supply, as is the situation with many other containers or found objects.

"Bird." Shoe horns form the neck and the tail of this perky bird. Body is wood covered with tin and painted black. Bloomington, Ill. High School.

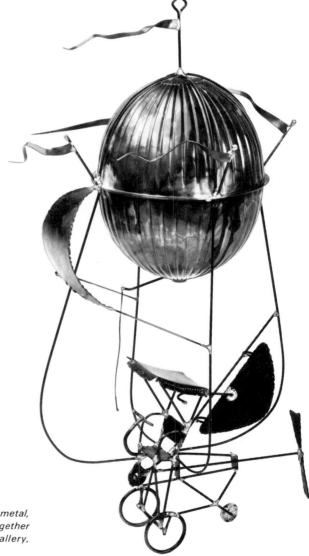

"The Peddle Craft Balloon." Bits of sheet metal, rods, and a metal water tank float welded together by Brian Wilson. Courtesy Wilson Gallery, Rochester, N.Y.

Fletcher Hodges, when age 12, completed this sculpture in the Brooklyn Museum Junior Membership Workshop. *

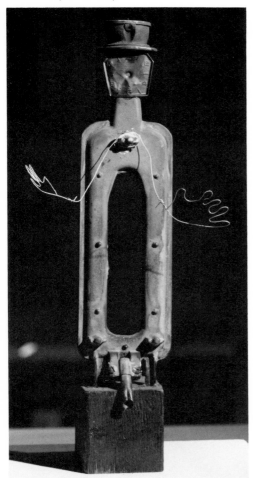

Section VII

WIRE AND METALS

For the artist who chooses to sculpt with scrap metal there is a tremendous profusion of available materials and sources, such as garages, farm yards, city dumps, factory scrap heaps, junk yards and industrial art shops.

Because of the durability of metals one may find pieces which were hand forged into intricate designs over a hundred years ago and have survived many years of exposure to the elements, gathering a delightful texture and color. There is the constant flow of newly fabricated pieces of diverse metals, distinctive textural finishes and plated surfaces discarded by manufacturers due to some slight imperfections. These pieces encompass an almost infinite array of interesting shapes. There are large flat sheets of steel, perforated sheets, cast pieces, bolts, nuts,

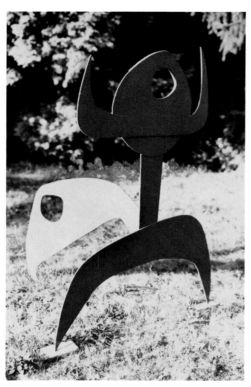

"Orange and Black," by Carl A. Reed. This five foot high steel sculpture was constructed from scrap steel waste. Pieces were welded together in "as found" shapes.

Only wire was needed to depict an active, alert dog. Knerr, Pratt Institute.

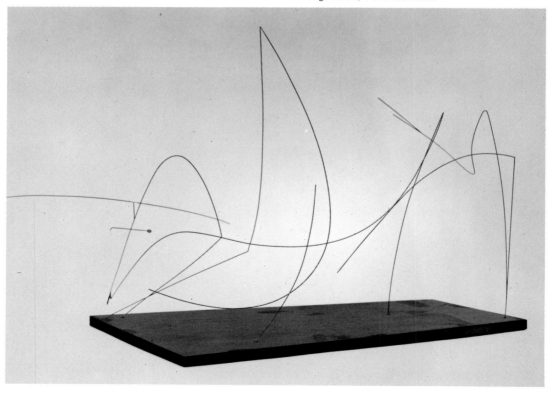

"Ironsides," by Joseph Marino. Scrap metal in the welding shop at the year end is used to do a creative sculpture at Trott Vocational High School, Niagara Falls, N.Y. Steven Polniak, welding teacher. *

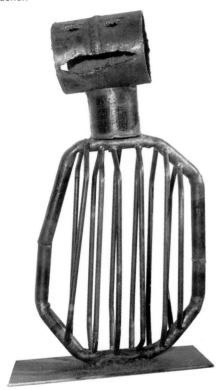

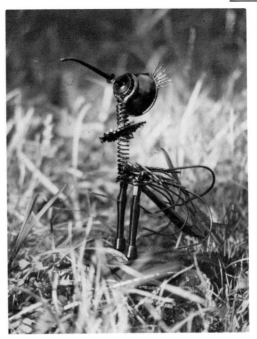

Michael Mandraccahia, age 14, used mails, a coil spring, coat hangers and an oil can in this sculpture. New Hyde Park, N.Y. High School. Esther Wohl, art teacher. *

gears, bars, pipes, rods, balls, chains and combinations all ready to be arranged into exciting and durable sculptures for indoor or outdoor exhibition.

Built-in obsolescence causes many mechanical units to reach the junk pile within a relatively short period of time following manufacture. Numerous parts are in unmarked and unworn condition. Many garages and repair shops are grateful for the removal of discarded pieces of metal. (Of course, some metals have a nominal reclamation value.) Discarded metals are of a host of materials, weights and shapes, such as: parts of heavy machinery, structural steel beams, automobile engines and accessories; brass clock works, and the wheels and gears in machinery; copper wires and steel cables; farm implements; heavy containers such as steel oil drums and light, tin or aluminum cans; in addition to copper scouring pads, steel wool and aluminum foil.

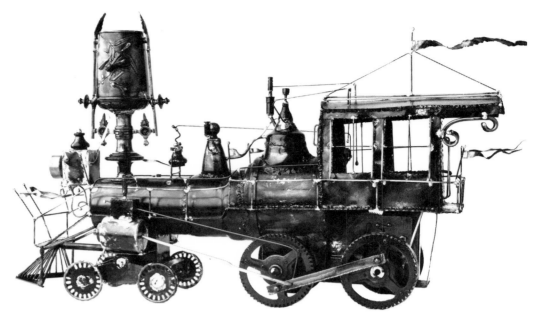

"The Bumble Bee Express," by Brian Wilson. Metal scraps, wires, rods, armature wafers from electric motors, gears from a 16 mm camera, with a smokestack made from an old metal goblet. Wilson Gallery.

Detail of tin can sculpture showing numerous surface patterns cut with the torch.

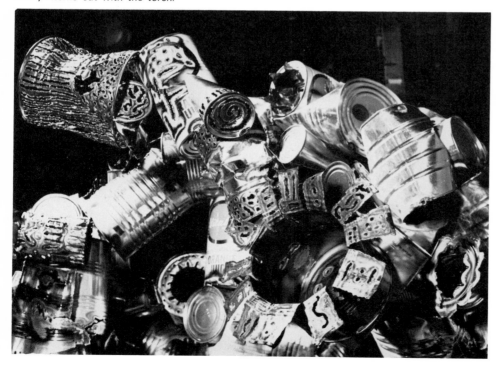

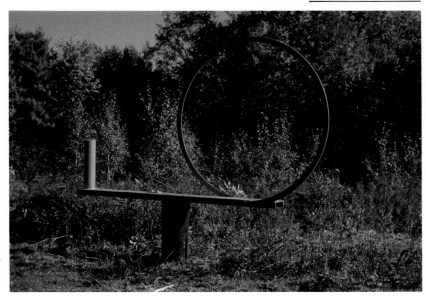

"Circle Stop" by Carl A. Reed. Circle of scrap steel welded to a garage oil pit support, mounted on a section of telephone pole.

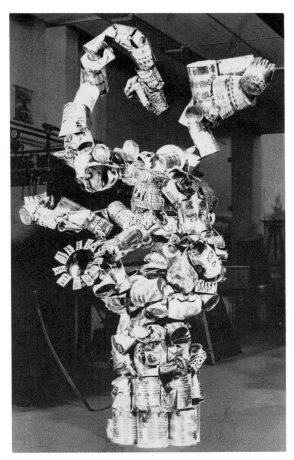

Tin can sculpture made with a welding torch. Courtesy Kener Bond, Nazareth College.

"Wounded Knee." The Indian good luck symbol rises above the white man's wrath as suggested by the blades from an old mowing machine cutter bar. Other metal is torch cut from a sidewalk, metal trap door. Carl A. Reed, Groton, Mass.

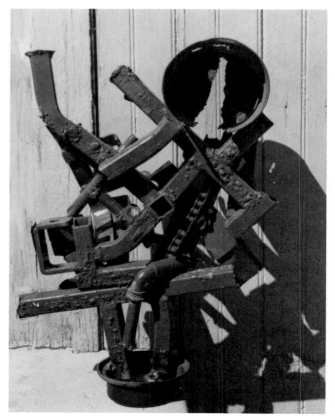

A bicycle chain, car parts and a tin can were the materials for a welded sculpture. New Paltz, N.Y. High School.

A box covered with aluminum foil, and features of aluminum foil pie plates joined with transparent tape were the elements for this mask.

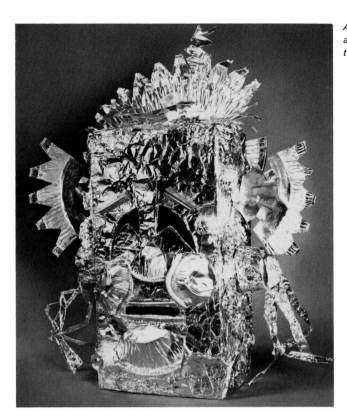

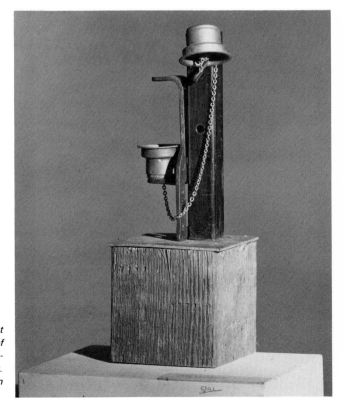

Meryl Spiro, age 11, created this found object sculpture. To circumvent the inherent dangers of oxy-acetylene welding, young students used Plio-Bond, an industrial cement, to join metal parts. Courtesy Lynn Kohl, Brooklyn Museum Workshop. *

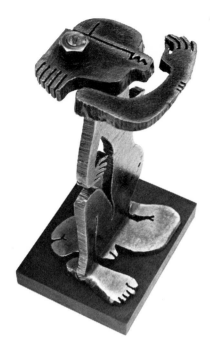

A 4" x 4" x 12" I-beam sculpture by Albert Leon Wilson. Wilson Gallery, Rochester, N.Y.

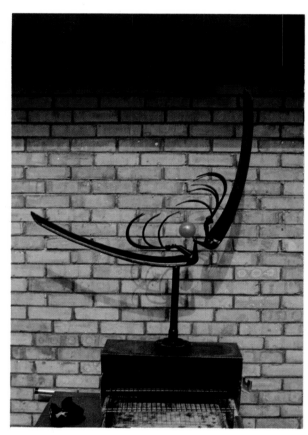

"Ball and Sickle" by Peter Jacobs.

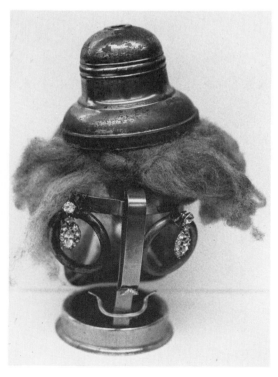

Junk sculpture using a vaporizer stand, steel wool, and rhinestone earrings, constructed with epoxy glue. Sheryl Miller, Lawrence High School, Cedarhurst, N.Y. Sylvia Schwartz, art teacher. *

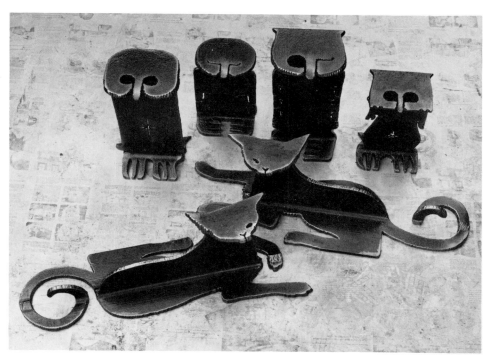

"Owls and Cats," by Albert Leon Wilson. Structural steel girders, or "I-beams," are used in creating these owls and cats and many other sculptures by Wilson. The sculptor searches out unusual beams at demolition sites and conceives each piece around deformities, scars, and colorations. The steel is fashioned with a flame of 6,000 degrees from an oxy-acetylene torch. The sculptor seldom bends the metal and never adds steel to the pieces.

While some metals may be easily collected and then cut into desired shapes with a hacksaw, tin shears or even scissors, there are heavier pieces that require an acetylene torch for cutting and shaping. Various metals may call for special techniques in joining parts during construction. While welding can be used for both large and small pieces, this is not a practical process for younger artists. For the student who may not be able to weld or solder, there are many adhesive materials which are easily used and have great strength. Liquid solder is practical for smaller pieces and there is a quantity of bonding putties which will join rather large pieces of metal. Patience is required when using these agents as the curing or setting time is often of several hours duration; thus the work progresses more slowly than when welding or soldering is employed.

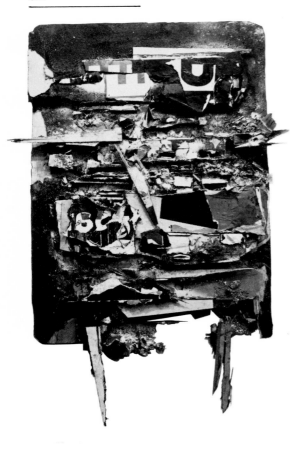

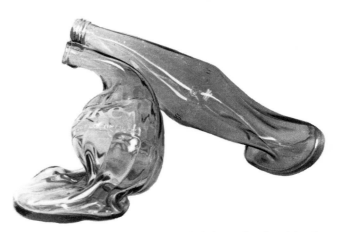

"Refreshing Pause." A Coke and a Pepsi bottle were blended into this sculpture by Jay Pokines of the Hoosick Falls, N.Y. Central School. The bottles were placed in a kiln, coated with extra wash, and heated to 1,250 degrees. No furniture was used. The photo was made by the artist.

"Broome St." by Robert Mallary. An assemblage of billboard tearings, splintered wood, sand, gravel, and other detritus, have been skillfully combined by a sensitive artist. Polyester was used to solidify ephemeral bits and pieces of matter into a permanent art form. Collection, Allan Stone, New York.

Peter Jacobs combined the base from an old bathroom sink with scraps of artificial fur to make an attractive composition of highly contrasting materials.

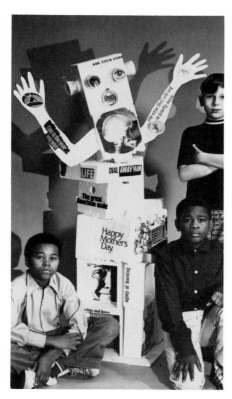

Styrofoam packing cartons, paper cups and magazine photos supplied these young artists with all necessary materials for a group sculpture project. Rochester, N.Y. City Schools. Towne photo.

Section VIII

MISCELLANEOUS OBJECTS AND MATERIALS

This book illustrates many sculptures that have been done from a wide assortment of articles. Each section of the text exhibits certain materials or types of containers which were used primarily in the sculptures illustrated there. However, this section presents an overview of creations done with various unusual materials and combinations of materials. Most of these pieces cannot be placed in any special category of substances.

Seeking out non-art materials and creating sculptures with them tends to develop one's sensitivity to all things in our environment . . . whether they be natural or man made. Many cast-off objects have attractive forms. When thoughtfully arranged or combined with other items they become even more attractive and dramatic. Often the application of color tends to camouflage the identity of a utilitarian object and emphasizes the contours or design.

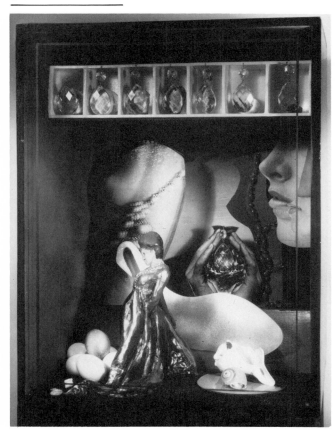

"Leda," by Harry Weisburd. Eggs (blown), snail shell, and pieces of jewelry are found objects. The hands and faces are photographs mounted on Plexiglas cutouts. Modeled objects in foreground are of fired clay. The two-foot high box is wood, spray painted with acrylic car paint, and the front is covered with a panel of Plexiglas.

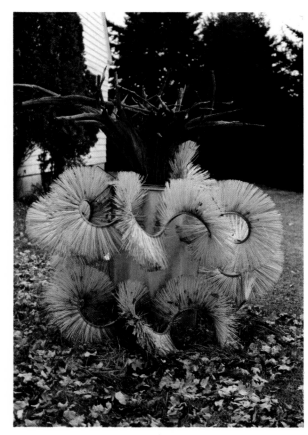

A metal drum from a fabric mill, a tree stump and roots, and an unwound coil of bristles from a street sweeping brush, provided Ray Miles of Amherst, Mass. with all the materials needed to create this interesting sculpture. New patterns evolve throughout the day as the sun alters the light and shadow patterns.

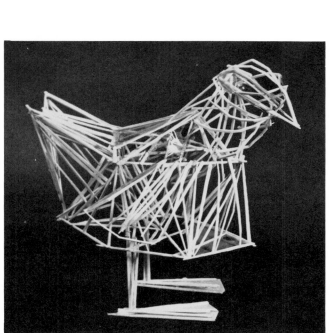

Toothpicks lend themselves to an unlimited variety of forms which are unusually sturdy, even when the structure is quite large. Light and flexible materials are readily combined with toothpicks. Rochester, N.Y. City Schools.

A twelve-year-old artist, George Del Fabbro, constructed a sculpture with white, extruded plastic foam packing materials, straight pins, plastic glue, a Styrofoam ball, and balsa wood supports. The ball was cured with glue so that it would not dissolve when it was sprayed with fluorescent paint. John Lesicko, art teacher, Delcroft School.*

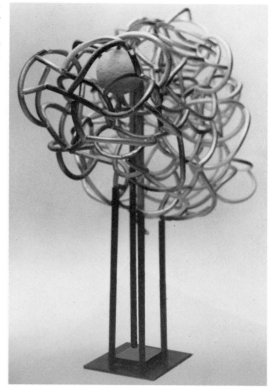

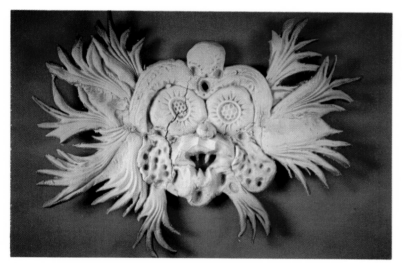

Cookie dough was cut and modeled to create this sculptured mask. Various found objects were pressed into the dough for decoration. Pamela Pomeroy.

"Tenement/Tenement People," by Dan Kelleher. A background of Masonite and acrylic paint has paint tubes attached with modeling paste. Here is a solution for the innumerable artists who have pondered what to do with the empty paint tube.

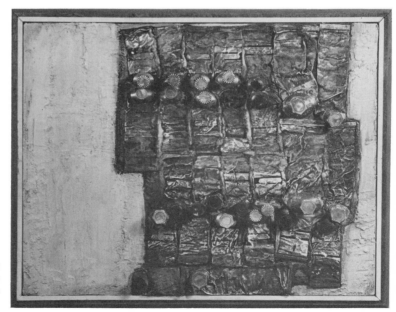

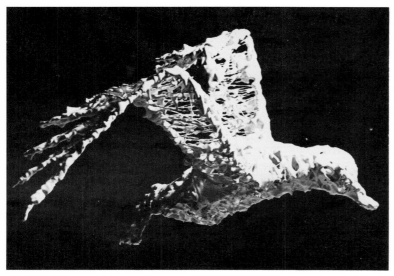

Heavy aluminum wire, combined with very fine wire, formed the basic structure for the bird. Then wet plaster was dripped over the wire. Karen Kane, Horseheads, N.Y. High School. Wilma Lundy, art teacher. Scharf Photo. *

"Eternal Texture," was established by using the lost wax process of bronze casting. The central area is the wax impressioned texture of aluminum foil. Surrounding this is an impression of the surface of a cinder block. When these textures were mounted on a flat blob of scrap wax, a bronze casting was made of the entire piece. Marguerite Goff.

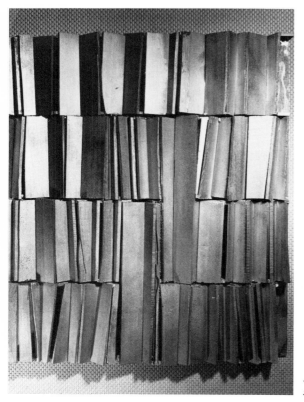

Scrap pieces of shingles were arranged to construct the rustic wall sculpture. Phillips Academy.

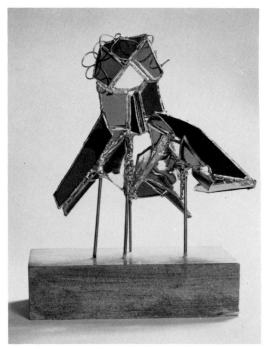

"Mother and Child." Slender steel rods support this imaginative sculpture from scraps of stained glass, copper foil, solder, and coiled wire. Marcie Hunter, Fort Lee, N.J. High School. Joan Di Tieri, art teacher.

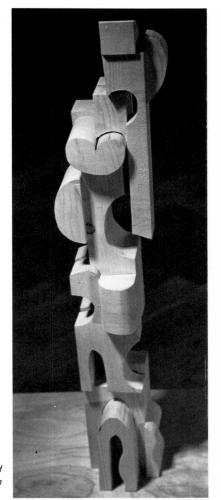

Wood scraps of incidental shapes were combined with planned shapes in order to develop this totem pole-like sculpture. Phillips Academy.

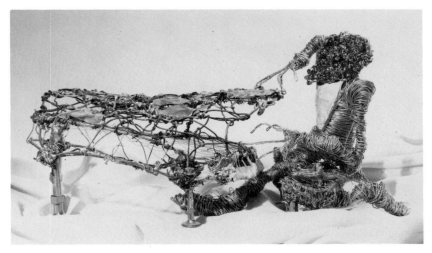

"Man Playing Piano," by Marcie Hunter, Fort Lee, N.J. High School. A door stop, a copper scrimer, copper wire, sheet copper, plaster, and solder.

A small class, conducted by Jack Smith of Southern Connecticut State College, spent one day at the dump and at the outdoor studio, in the process of constructing this monumental sculpture from found objects. The diversity of materials was made homogenous by a coat of black paint which was accented by orange stripes. Bonadies photo.

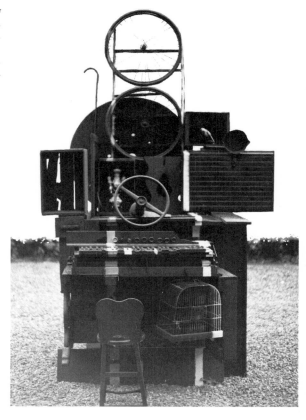

A stone shaped like a horse head prompted the addition of a few painted details.

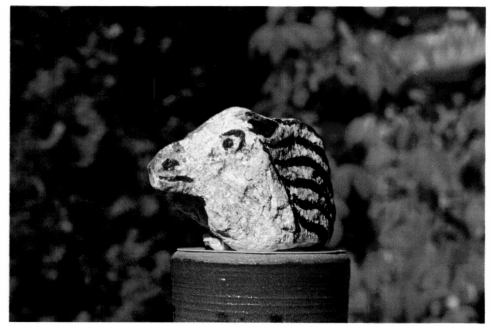

"Sycorax." Old wood, metal, welded rods, sand and gravel, polyester putty, canvas, rubber, sheets, and fiber glass are combined into an integrated work of art by the perceptual, technical, aesthetic, and organizational genius of an accomplished artist. The upper part of the anthropomorphic sculpture was cast into a semi-rigid and very stretchy mold of canvas and rubber sheet. Most of the modeling had to be done from the back. First a canvas was stretched, then several round and oval holes of various sizes were cut into the canvas. Over this a rubber sheet was stretched and the surface covered with polyester. As the rubber sheet sagged into the holes of the canvas the depths of the depressions were extended by adding sand for weight. This produced the smooth bulbous surfaces and the stretched rubber on the taut surface of the canvas resulted in the contrasting crinkly texture. The interior was strengthened by fiber glass and welded rods. Collection Whitney Museum of American Art. Photo courtesy of the artist.

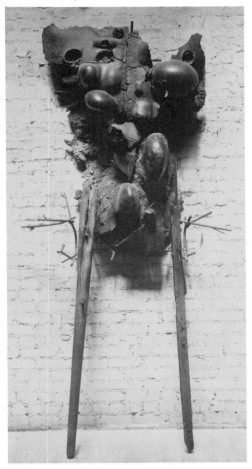

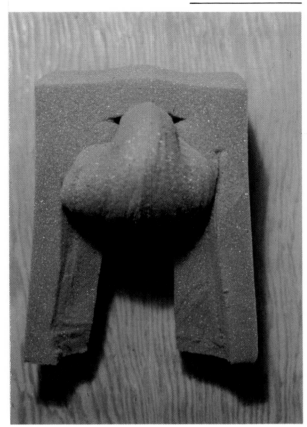

An abstract head formed by cutting a rubber sponge and folding the sliced section back into a slit in the top portion. The Groton School.

Sometimes when two different objects or materials are combined, both objects lose their original identity. In some instances only the texture of articles is needed to produce attractive pieces. In other cases, a commonplace object, such as a glass bottle, can be reshaped by heat into an aesthetically sculptural form.

It becomes evident from the illustrations in this section that the alert, perceptive person need never be without materials with which to create. Sophisticated sculpture can be developed from such diverse materials as: artificial hair, bird cages, berry baskets, bottles, cookie dough, frying pans, jewelry, lace, organ keyboards, paint tubes, plywood, posters, shingles, shoes, sink stands, street brushes, stockings, Styrofoam, tree roots, toothpicks and wire.

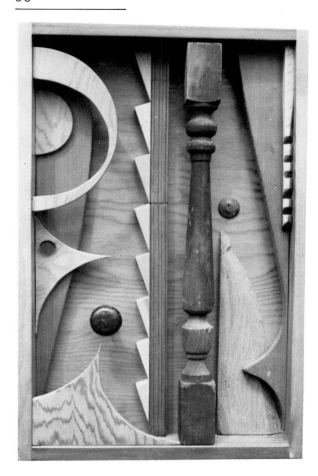

Assemblage from wood scraps by Larry Wilcox. Contrast between new and aged wood was emphasized. Elizabeth Stein, art teacher, Bloomington, Ill. High School.*

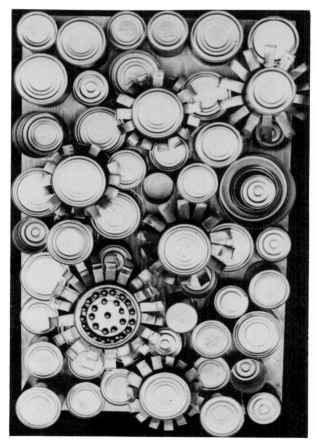

Student sculpture. Tin cans cut and arranged before spraying with silver paint. Thelma Stevens, art teacher, West Hempstead, N.Y. High School.

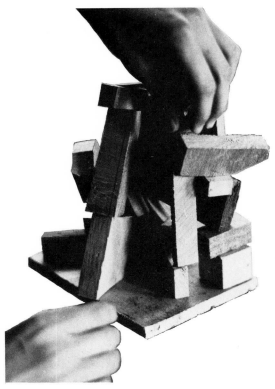

Scrapwood being arranged without joining any parts. Photo by John Glancy, New Paltz, N.Y. High School.

Section IX

EXERCISES IN CREATIVITY WITH DISCARDED MATERIALS

A large supply of solid items, such as found objects or containers, can provide the necessary materials for use in an art classroom for experimental arrangements or creative problem solving . . . which is what art is all about.

Some instructors provide boxes of a single material such as scrap wood (usually leftover pieces from an industrial art shop) and the students are challenged to assemble selected pieces into interesting compositions. Other teachers provide a variety of materials and students are encouraged to select a number of items with which to experiment. The students work singly or in groups and often their structures are arranged without joining parts

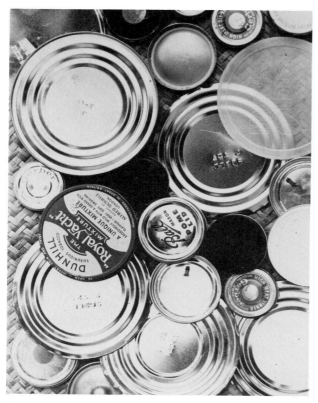

Can covers arranged on a raffia mat to emphasize transparency, color and texture.

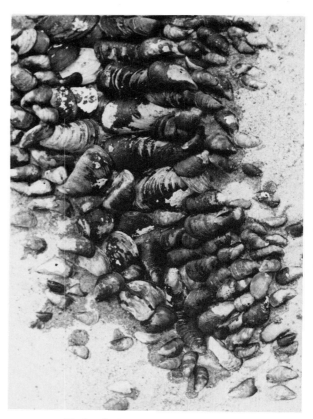

Shells of different sizes and colors arranged in a sandbox.

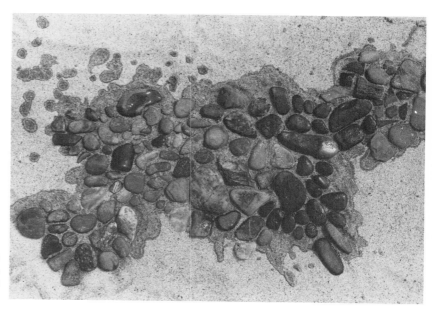

Stones provided the challenge for a creative arrangement in a box of sand. Water was used to emphasize the texture and color of stones and to add to the design pattern.

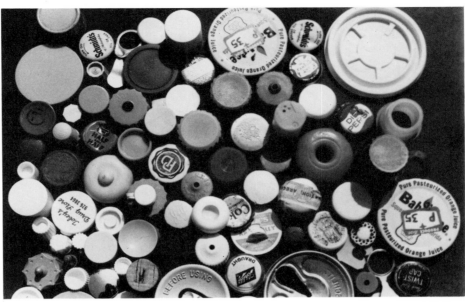

Tops of bottles, jars and cans provide a variety of sizes, shapes, colors, materials and textures for arrangement problems.

Fifth grade students, in groups varying in sizes from three to nine, worked out arrangements using boxes and other containers. California Avenue School, Uniondale, N.Y. Richard Grillotti, grade teacher.

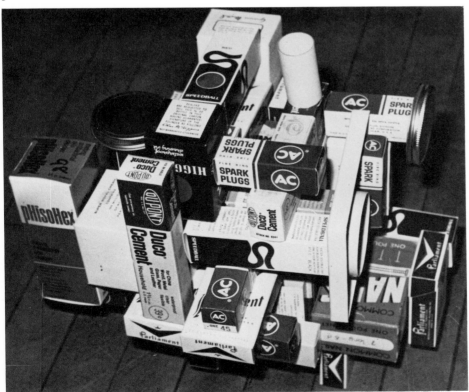

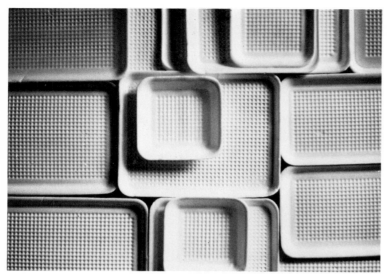

Styrofoam meat trays provide all necessary materials for problems in arranging square and rectilinear forms in white on white patterns.

Discs cut from meat trays may be arranged in endless curvilinear patterns.

High school students team up to solve the challenge of creating a three-dimensional sculpture with flat pieces of paper. East High School, Rochester, N.Y.

Students worked many hours to arrange this exciting combination, of shapes, colors, and patterns. Richard Grillotti, fifth grade teacher.

together. When unusually interesting forms have been created, students may be encouraged to join the separate pieces in order to make a permanent arrangement. This arrangement may then be painted or decorated in some other way. However, the major developmental factor in activities of this type is to encourage freedom of experimentation and exploration and not to design finished pieces. The process (the creative process), not the product, is the important element.

All of the objects used in the illustrations in this section are easily recognizable and readily obtained. The materials are of such durable quality that they could be used repeatedly by students of various ages. Futhermore, developing aesthetic arrangements with the items shown provides a challenging activity for any age level. Of course, there is an almost endless number of items that can be collected and used in creative exercises.

Some instructors establish a "library" of found objects for use in art activities. Materials are sorted into categories and boxed and labeled accordingly. This procedure of cataloging also encourages students to seek out objects to add to the collection.

CREDITS

The source of most photographs (not done by the authors), the artist, the school or college and the art teacher involved, where pertinent, has been noted with the illustration caption. However, there are several people and sources to whom the authors are especially grateful for their generous assistance and extensive contributions.

Elizabeth Stein, a former art teacher, provided all of the illustrations of work done by her Bloomington, Illinois High School students. She also did the photography of those works. Joan DiTieri, art teacher at Fort Lee, New Jersey High School supplied all photos of work done at her high school. Dan Kelleher of Erie, Pennsylvania, provided a selection of his own work and that of his students. Bartlett Hayes granted permission to photograph several pieces of student work done at Phillips Andover Academy, Massachusetts. Robert Mallary supplied numerous photos and described techniques which he has used in his sculptures. Thelma Stevens of West Hempstead High School and Sylvia Schwartz of Lawrence High School, New York submitted a large selection of their students work. Margaret Steinhauser art teacher at Trott Vocational High School submitted photos of sculpture done in the welding shops. Albert Christ-Janer provided many photos of student work from Pratt Institute, New York. Lynn Kohl made available photos of work done in the workshop of the Brooklyn Museum. Students and teachers at East High School in Rochester provided many excellent illustrations and several Rochester art teachers made available works of their students and works done in teacher work shops. The Wilson Gallery in Rochester was the source of a wide supply of sculpture photos. *School Arts* magazine kindly permitted the use of several photos which had previously appeared in the magazine. All such photos are noted with an asterisk at the end of the caption.